STEAMPUNK
& COSPLAY
fashion design & illustration

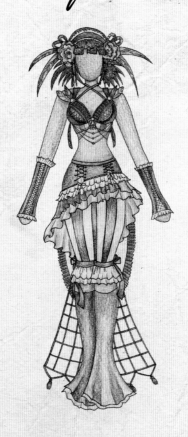

by Samantha R. Crossland

Walter Foster

Fashion illustrations on cover and pages 1, 32–41, 45–49, 53–55, 61–65, 69–73, 79–83, 87–89, 93–95, 99–103, 107–111, 115–117, 121–123, 126, and 127 and photograph on page 12 © 2015 Samantha R. Crossland. All fabric swatch photographs © Shutterstock, except on pages 24 ("Bouclé"), 25 ("Canvas"), 26 ("Flannel"), 27 ("Herringbone," "Houndstooth," "Khaki," "Lace"), 28 ("Poplin," "Suede"), and 29 ("Toile") © 2015 Samantha R. Crossland. Photographs on pages 6, 7, 10 (inset), 11, 13, 14–17, 50 (bottom right), 51, 56 (hat), 59 (center), 66, 67, 73 ("Footwear"), 74 (watch), 84 (center right), 86, 90 (goggles, compass), 95 ("Mustache Variations"), 96, 98, 104, 105, 112 (clock), 113, 114, 118 (bottom left and right), 119, 120, and 124 (top right) © Shutterstock. Artwork on page 18 © 2009 Eileen F. Sorg. Artwork on pages 22, 23, 30, and 31 © 2011 Stephanie Corfee.

Cover design by Colin Mercer

Photographs on front cover and page 4 © Ryan Blomquist

Additional photography (used with permission): Photographs on back cover and pages 52, 56, 57, and 112 © Christie Rachelle; photographs on pages 8 (left), 56 (bottom right), and 59 (top right) © Brian Barnes Photography (www.bebfoto.com); photographs on pages 8 (bottom center), 9 (top left), 42, 44, 45 (top), 53, 58, 68, 75, 77 (bottom photos), 78, 79 (top), 90 (top right), and 124 (bottom left) © Carla Haglund; photographs on page 10 (left), 45 (bottom), 59 (bottom left), 77 (top left), and 128 © PhotoSynthetique; photographs on page 50 (top left and right, center left) © Flash City Photography; photograph on page 60 © Dim Horizon Studio; photograph on pages 9 (right) and 69 © 2011 Rome Celli; photographs on pages 74, 76, 90 (bottom left and center), 118 (top left), and 125 © Rhea Pappas; photographs on pages 79 (bottom) and 84 (bottom left) © Rebecca J. Ulasich, Liminality Photography; photographs on pages 84 (top right), 85, and 106 © Kristin Berwald; photograph on page 91 © Donna Machen and Tyler Peterson; photographs on pages 92 and 97 © JRD Photography.

Text on pages 8 and 9 written by Joey Marsocci and Allison DeBlasio

Publisher: Rebecca J. Razo
Creative Director: Shelley Baugh
Production Director: Yuhong Guo
Senior Editor: Stephanie Meissner
Managing Editor: Karen Julian
Design Coordinator: Lawrence Marquez
Page Layout: Andrea Martin
Editorial Assistant: Julie Chapa
Production Designer: Debbie Aiken

Walter Foster

www.walterfoster.com
6 Orchard Road, Suite 100
Lake Forest, CA 92630

Printed in China
10 9 8 7 6 5 4 3 2 1

TABLE OF CONTENTS

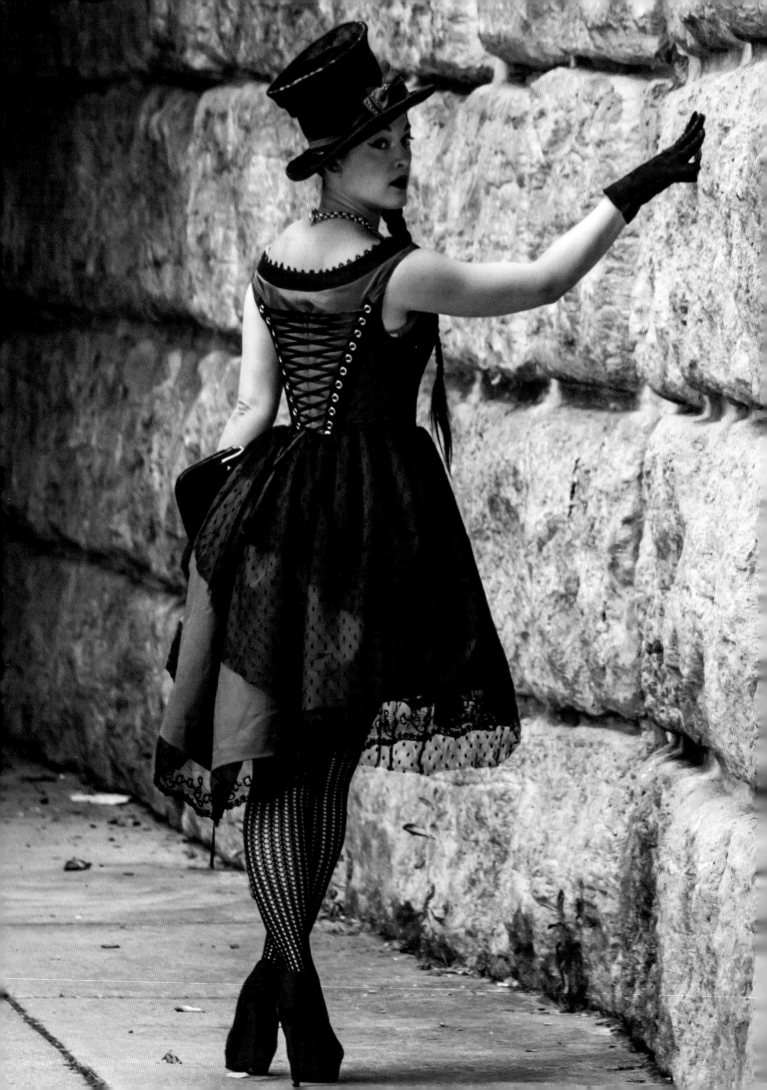

INTRODUCTION

FASHION IS AN AMAZING WAY to tell a story. I have always been compelled to tell stories, but never have I been able to do so more articulately than with design.

I got my start in alternative design, namely Gothic and Lolita. There was a lot of crossover with Neo-Victorian and Steampunk fashion, so I was able to tell a great deal of stories. Even though I have now crossed over into a more mainstream aesthetic, historical and subculture fashion still influence me.

Some of my biggest design inspirations are Alexander McQueen, Marchesa, John Galliano, Anna Sui, House of Wirth, Vivienne Westwood, Prada, Novala Takemoto, Hirooka Naoto, Jean-Paul Gaultier, Marc Jacobs, Mary Katrantzou, and Valentino. From construction to vision, I strive to be counted among the greats I consider my heroes.

Many designers create daring, alternative visions. Some conceive gentle stories. All of them make a mark. Now it's your turn...

Samantha R. Crossland

DEFINING STEAMPUNK

STEAMPUNK IS A POPULAR ARTISTIC MOVEMENT that spans many genres, including fine art, music, performance, fashion, graphic design, and others; however, the inspiration for this steam-driven, industrial utopia filled with Victorian sights, textures, haberdashery, and otherworldly technology was originally born in ink from the masters of science-fiction literature.

Tales of adventure penned by the literary innovators of their time sparked steampunk to life. Mary Shelley's *Frankenstein* (1818) bridged the gap between ancient mythology and the imagination of science, thereby paving the way for the genre's earliest origins. A few years later, the innovative literary techniques in Edgar Allan Poe's horror stories emerged. Then Jules Verne began blending the styles of Poe and Shelley into his cornerstone works, *Journey to the Center of the Earth* (1864) and *20,000 Leagues Under the Sea* (1869). In 1889, Mark Twain pioneered another foundational notion of steampunk with the concept of time travel in *A Connecticut Yankee in King Arthur's Court*.

H. G. Wells is often linked to steampunk, most notably for coining the term "time machine" in his work *The Time Machine* (1885), and he continued to perfect the science-fiction genre with *War of the Worlds* (1898). H. P. Lovecraft, a contemporary of the scientific minds associated with steampunk, designed a sophisticated blend of alternate dimensions and apocalyptic settings in a fictional universe known as "Cthulhu Mythos," which he created in 1925. Today many of these works are taught in high school and college literature courses. In addition to the contributions of these literary figures, the innovations, theories, and ideas of such brilliant minds as Nikola Tesla, Thomas Edison, Albert Einstein, and others also influenced the evolution of steampunk. And many of their ideas thought to be impossible eventually became reality as science took center stage in the late 19th century.

In 1987, science-fiction and horror author K. W. Jeter coined the term "steampunk" to define the works of his peers, authors Tim Powers and James Blaylock. Jeter couldn't have foreseen that the trend would later grow into a cultural movement.

Today steampunk is most prevalent in the art and role-playing communities. Fans dressed in elaborate costumes brandishing antiquated-looking props gather at steampunk balls, conventions, and tea parties around the world. Many steampunk artists even sketch ideas that they eventually develop into inventions of modified technology, such as operable computers and phones.

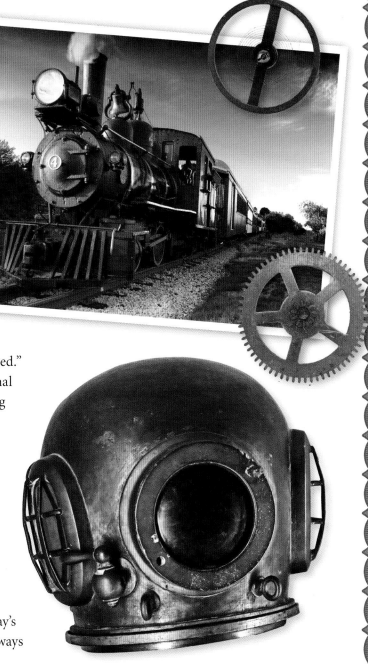

There are two common principles on which most steampunk artists and inventors tend to agree. The first is that steampunk embodies a "time that never happened." Anachronism does not exist in an artist's fictional world because technology can develop according to the creator's imagination. The second principle is that the materials used to create costumes, props, and other works of art are at least in part characteristic of the 19th century; therefore, steampunk artists often employ brass, copper, wood, and leather, along with industrial mechanisms, clocks, and assorted machine parts, to create their wondrous inventions. And just as the creators of steampunk envisioned fantastic technological advances beyond the limitations of their era, today's steampunk artists are forever dreaming up new ways to bend reality from a time that never was.

Definition of Steampunk

Central to the definition of steampunk is a discussion of the words "steam" and "punk." The word "steam" is not a literal description. In fact, a lot of steampunk art does not even contain steam technology. Rather, "steam" refers to the era of steam technology—the 19th century. The word "punk" invokes the idea of rebellion (just as it does in music) against the modern manufacturing aesthetic. However, it is up to each artist to determine the ratio of "steam" to "punk" in his or her work.

HISTORICAL INSPIRATION

STEAMPUNK, *LOLITA*, AND OTHER ALTERNATIVE FASHIONS in this vein are so much fun because they are historical fashions as seen through a modern lens. "Steampunk" started out as merely a literary term. It is a subgenre of science fiction/fantasy that usually describes the late 1800s through the very early 1900s in an alternate world with more advanced technology.

Depending on the era in which a story takes place, there are other similar offshoots, such as *Clockpunk* (Renaissance), *Dieselpunk* (mid-1910s to mid-1940s), *Decopunk* (1920s-1950s), or *Atompunk* (mid-1940s to mid-1960s).

The term "Steampunk" was coined in the 1980s by author K. W. Jeter as a way to describe stories in Victorian and Edwardian times with more technological advances. In the 2000s, the style was adopted into its own genre of alternative fashion. There are now Steampunk clothing labels, bands, conventions, and events all over the world.

Lolita fashion derives from a few places. This style, while inspired by Western fashions, had its start in Japan in the 1970s. Lolita is rooted in *otomekei*, or "girly-style;" it has evolved over the past few decades into what it is today. When *otomekei* started to become what Lolita is now, it was heavily influenced by Victorian and Edwardian fashion, as well as modern gothic- and prairie-style clothing, such as Gunne Sax.

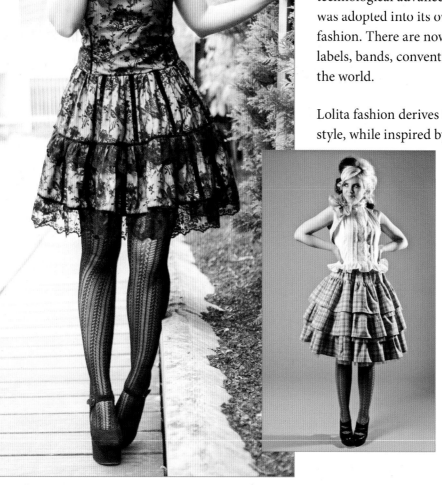

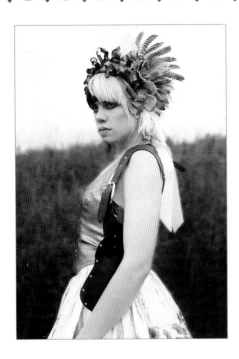

Between the late 1990s and early 2000s, with the help of the Internet, this style became accessible to fans of Japanese pop culture in the United States. While fans had their own take on the style, due to the inability to order the clothing from Japanese shops, most adherents to the style tried to stay true to the original look. A handful of small online shops opened in the United States and Canada in the early 2000s to try and bridge the gap.

In the mid-2000s, with the release of the book and film *Kamikaze Girls* by Novala Takemoto, Lolita started to take on influences from Rococo-era fashion, adding more trims, candy colors, and embellishments. Japanese shops opened up to international sales, and the style became incredibly accessible worldwide. Classic, Gothic, and other styles still have a strong historical influence, but styles like Sweet and Deco have a much more modern twist.

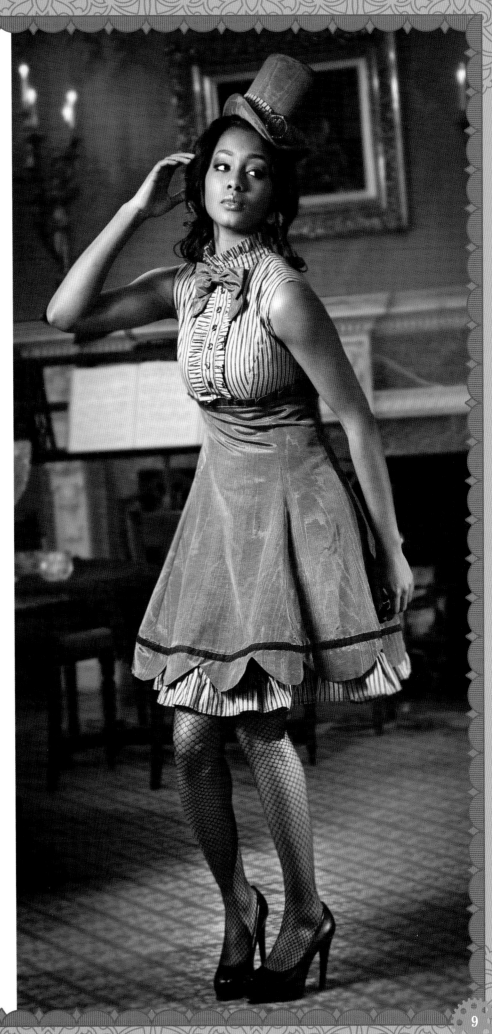

RESEARCH & FORECASTING

WHEN DESIGNING A COLLECTION, or even a single look, it is incredibly important to *research* and *forecast*. Whether you're making something for a presentation or for sale, if you make a garment that isn't appealing, no one will want to wear it.

RESEARCH

Research the market, the influence, and the materials. If you are making a garment or collection based on 1890s military looks, narrow down *which* military style works for your collection. One thing many people don't take into account when drawing influence from a specific historical time period is that there are several things happening in the world at any given time. History did not only take place in the United States and England. Eastern Europe, Northern Africa, and the Far East all have rich histories that can provide lush inspirations. Use historical research as a jumping-off point to look up embroidery and hand-sewing techniques, methods of fabric folding, or differences in embellishments.

Who is the customer? Will this affect what you design? If your client or friend has a specific style, making something that does not appeal to them will not be successful. What kind of fabric will hold the shape you're trying to achieve? Will it go well with the collection or look? These are all important questions to ask before finalizing a look or cutting into fabric.

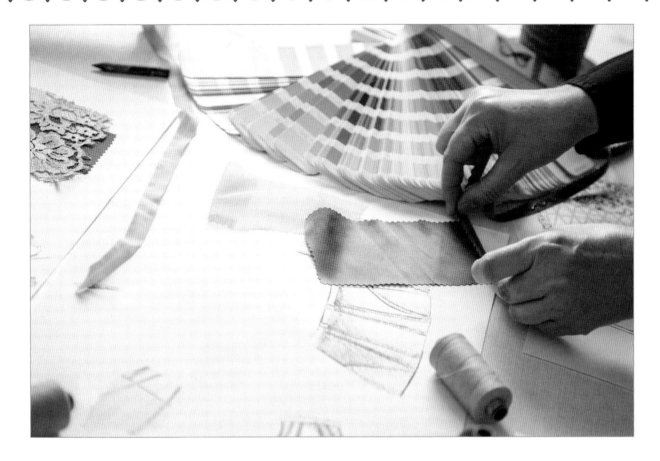

FORECASTING

Forecasting is the practice of looking at where trends will be going. A lot of research is required to develop the ability to keep your finger on the pulse of your specific market. This is not just important in mainstream fashion. To be successful in the fashion industry, no matter the genre, one must be able to predict what the customer base will want in the next few seasons. Labels that are stale rarely make it.

The fun thing about alternative styles, such as Steampunk and Lolita, is that there is a lot of room to set the trends yourself! Quite often, mainstream designers use alternative fashion as an inspiration, thus making it more accessible to everyone. For instance, the Fall/Winter 2012 menswear collection for Prada was heavily influenced by Steampunk. The popular band Panic at the Disco also had a Steampunk music video, utilizing the skills of independent designers and stylists.

Similarly, mainstream styles can cross over into alternative fashion. Buy fashion magazines, read fashion style blogs, go to malls with a large population of young adults, and watch TV shows that include creative costuming and styling. Paying attention to these things will help you figure out where fashion is going to go next. Do, however, continue to innovate. Yours might be the look that inspires the next big designer!

MOOD & INSPIRATION BOARDS

MOOD BOARDS AND INSPIRATION BOARDS get the ball rolling creatively. A mood board is like a collage or bulletin board where you can flesh out the feeling you want your collection or ensemble to have. Let's say you want to create a sense of whimsy and nostalgia. You may use clippings from country wedding magazines, children's book illustrations, and photos of meadows. As you work on this collection of images, you might feel more strongly for some and decide you don't like the feeling of others. This is how you organize your "pre-inspiration" inspiration.

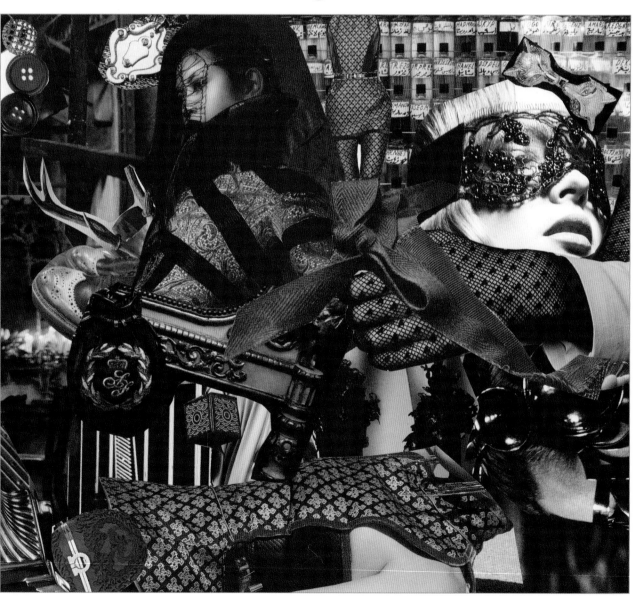

An inspiration board is where you start collecting actual looks you like. Consider the collection inspired by whimsy and nostalgia. You might collect images of flowing white sundresses; knee-high, brown, lace-up boots; and fuzzy sweaters. As you're combining images, you might decide you like cardigans specifically, instead of pullovers. Perhaps you like the bow on one neckline, but the skirt on another dress. Maybe you could make something similar in silhouette, but longer and in a different color...

Designers are artists, and their medium is clothing.

Sometimes a designer has an idea on the tip of their brain that doesn't quite emerge until they see something similar. This is why so many items that are on trend look similar, yet completely different. Designers are artists, and their medium is clothing. Two painters might paint the same mountain, but it won't look the same. Inspiration boards help you create your mountain. A great tool for creating inspiration boards is Pinterest®. You can make your boards public or private, share them with your friends, request that clients share them with you, and organize your thoughts and ideas.

When compiling your boards, take a few things into account: *Color Story*, *Garment Purpose*, and *Cohesiveness*.

COLOR STORY

A color story is the collective group of colors that you use in a collection or outfit. As a designer, you want to ensure the colors are current to trends, cohesive, and flattering. Take into account what the client looks like. Will the colors be flattering with his or her hair or skin tone? Are the colors complementary to one another?

PURPOSE

What purpose will this garment serve? This is very important to consider. If you're creating a Steampunk military ensemble, you probably don't want to make a bikini—or maybe you do! I won't judge. In all seriousness, however, consider what you, your client, or your customer base would want for this look. If it is for a wedding, you'll probably want to use high-end, luxurious fabrics. If it is for daily wear, it should be comfortable.

COHESIVENESS

Cohesiveness means ensuring that all of the pieces go together in a way that makes sense. If you're designing a collection of gowns, you don't want to add a jumpsuit; it won't make sense and may confuse your clients or audience. If you're designing a Weird West look for yourself, you don't want to top it with a sailor hat. Remember, even alternative fashion has trends, and if you are making a collection for sale or even just to wear to an event, you should take this into consideration.

TOOLS & MATERIALS

DRAWING SUPPLIES

DRAWING PAPER

Drawing paper comes in many sizes and finishes. For pencil work, I recommend 50-lb. sketching paper. This paper is also great for coloring with colored pencils. If you plan to ink your fashion illustrations or add color with markers, use a smooth, heavier paper, such as 100-lb. Bristol paper.

PENCILS

Graphite drawing pencils are designated by hardness and softness. H pencils are hard and make lighter marks; B pencils are soft and make darker marks. Pencils range from very soft (9B) to very hard (9H). For fashion drawing, I prefer mechanical pencils because they are great for line quality and consistency of sharpness.

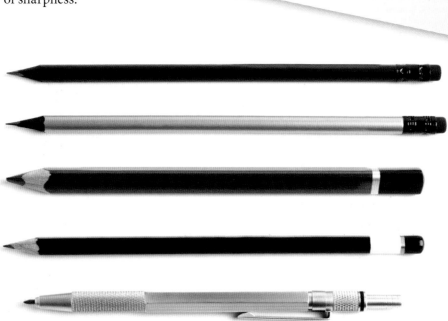

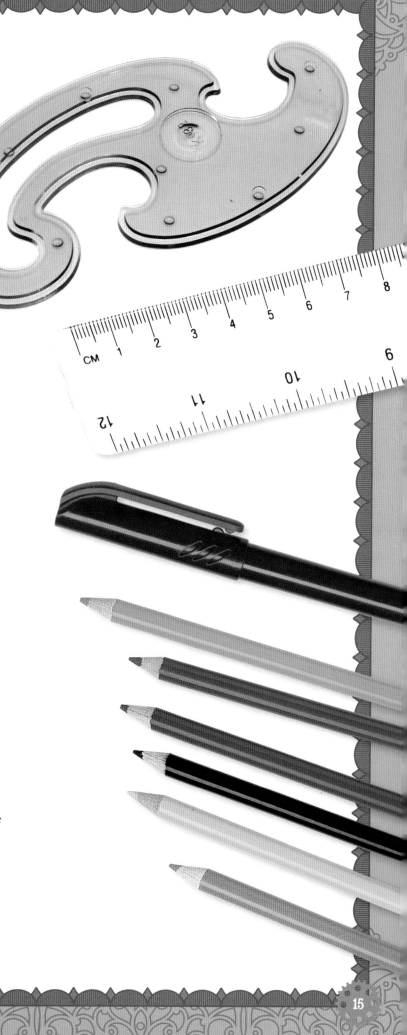

RULER & FRENCH CURVES

It's always helpful to have a straight-edge ruler handy, and a French curve will help you achieve pretty flowing lines and rounded edges.

PENS & MARKERS

For inking your final drawings, you'll need archival ink pens or artist pens. There are many quality brands of drawing pens available at art & craft stores. Experiment to find the kind that you like best! These pens come in various nib sizes.

WATERCOLOR PENCILS & COLORED PENCILS

Watercolor pencils are great for a controlled and tidy application of color that can be "smoothed out" with a little water—just be sure to use them on watercolor paper! Standard colored pencils are excellent for adding color with a bit of "tooth" and texture.

PAINTING SUPPLIES

PAINTS
You can add color to your fashion illustrations with watercolor, acrylic, or gouache paints.

PAINTBRUSHES
Paintbrushes come in a variety of shapes and sizes; specific shapes and brush types are best for different purposes, such as a round brush with soft hairs for watercolor or a flat brush for creating straight edges and strokes of uniform width.

WATERCOLOR PAPER

Watercolor paper is a textured paper that works best when using acrylic or watercolor paints, as well as gouache and ink.

DIGITAL TOOLS

COMPUTER & SCANNER

Computers and other hardware are essential for creating digital files, tweaking colors, cleaning up stray lines, editing source photos, and printing copies.

PHOTOSHOP®

Photoshop, or similar photo-editing software, allows you to make dramatic enhancements with just few clicks of a mouse. I use Photoshop for cleaning up artwork, as well as adding color.

DRAWING TECHNIQUES

WARMING UP

Warm up your hand by drawing random lines, scribbles, and squiggles. Familiarize yourself with the different lines that your pencils can create, and experiment with every stroke you can think of, using both a sharp point and a dull point.

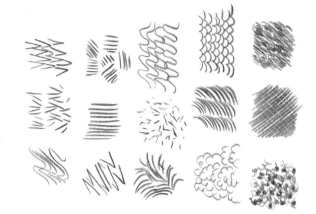

TYPES OF STROKES

Circular Move your pencil in a circular motion, either randomly (shown here) or in patterned rows. For denser coverage, overlap the circles. Varying the pressure creates different textures.

Linear Move your pencil in the same direction, whether vertically, horizontally, or diagonally. Strokes can be short and choppy or long and even.

Scumbling Scribble your pencil in random strokes to create an organic mass. Changing the pressure and the amount of time you linger over the same area can increase or decrease the value of the color.

Hatching Sketch a series of roughly parallel lines. The closer the lines are to each other, the denser and darker the color. Crosshatching involves laying one set of hatched lines over another, but in a different direction.

Smooth No matter what stroke you use, if you control the pencil, you can produce an even layer of color. You can also blend your strokes so that you can't tell how color was applied.

Stippling Sharpen your pencil and apply small dots all over the area. For denser coverage, apply the dots closer together.

COLOR BASICS

Color means everything in fashion design, so it helps to know a bit about color theory. There are three *primary* colors: red, yellow, and blue. These colors cannot be created by mixing other colors. Mixing two primary colors produces a *secondary* color: orange, green, and purple. Mixing a primary color with a secondary color produces a *tertiary* color: red-orange, red-purple, yellow-orange, yellow-green, blue-green, and blue-purple. Red, orange, and yellow are "warm" colors, whereas green, blue, and purple are "cool" colors.

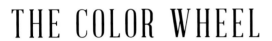

THE COLOR WHEEL

A color wheel is useful for understanding relationships between colors. Knowing where each color lies on the color wheel makes it easy to understand how colors relate to and react with one another. Colors directly across from one another, like yellow and purple, are *complementary*. Colors next to each other, like green and blue-green, are *analogous*.

COLOR MIXING

Color mixing is one of the most enjoyable parts of fashion design. Use this handy guide to practice creating color combinations—then experiment creating your own!

Red + Yellow = Orange

Green + Blue = Blue-Green

Blue + White = Sky Blue

Blue + Red = Purple

Purple + Red = Red-Purple

Purple + White = Lavender

Yellow + Blue = Green

Green + White = Mint Green

Yellow + White = Pale Yellow

Orange + Red = Red-Orange

Red + White = Pink

Orange + White = Peach

FASHION TERMS

BELOW ARE SOME COMMON TERMS in the Steampunk
and Cosplay fashion world.

APPLIQUÉ
A cut-out design that is sewn onto a garment as an embellishment or decoration

BALDRIC
A belt for a weapon worn over one shoulder and down to the opposite hip

BEND
A waistcoat, vest

BILLY
A handkerchief (often silk)

BODICE
The top of a garment that covers from the neck to the waist or hip

BONING
Stiff strips made from polypropylene or spiral steel, which are sewn into vertical seams of a corset or dress bodice to help with shaping, structure, and fit

BRACER
A guard or band worn over the wrist; traditionally worn in archery on the bow hand to protect it from the snap of the bowstring

BUSTIER
A woman's close-fitting, sleeveless, strapless top, usually with boning to give it shape

CAPELET
A short cape that usually covers just the shoulders

CLOCHE
A woman's close-fitting hat with a deep, bell-shaped crown and often a narrow, turned-down brim

CORSELET
A woman's lightweight foundation garment, combining a brassiere and girdle in one (also *corselette*)

CORSET
A form-fitting top or undergarment with stiff, vertical boning support

CRAVAT
A short, wide piece of cloth worn around the neck by men with its ends tucked inside the shirt collar

DART
A folded wedge of fabric that is tapered and stitched down to give shape to a garment

DOUBLET
A man's close-fitting jacket

EMPIRE WAIST
The style of a dress or top where the waistline is placed high up under the bust

EPAULET
An ornamental shoulder piece, typically on the coat or jacket of a military uniform

ERSATZ
Copied from something else; a replacement material

FLOSSING
Silk filaments with little or no twist, used in weaving as brocade or in embroidery

GAUNTLET
A dress glove that extends above the wrist

GODET
A triangular piece of fabric sewn into a garment to add fullness; also referred to as "gores" or "gussets"

HIGH WATERS
Trousers short enough to expose the ankles

JABOT
An ornamental frill or ruffle on the front of a shirt or blouse, usually made of lace

PITH HELMET
A light, hard hat worn for sun protection

PLEATS
A method of adding structure and volume to fabric by doubling it back on itself and then stitching it in place. Pleats can be soft (unpressed) or sharp (pressed)

RUCHING
The gathering of fabric along a seam line that creates soft folds and draping on a garment; also referred to as "shirring"

SELVAGE

The edge of woven fabric finished to prevent raveling, often in a narrow tape effect and different from the body of the fabric

SLEEVE GARTER

A garter worn on the sleeve of a shirt that allows men to customize sleeve lengths and protect the cuffs while working

SMOKING JACKET

A loose jacket or robe worn by men at home

SPAT

A cloth or leather gaiter covering the instep and ankle

SURCOAT

An outer coat made of rich material

TAILCOAT

A man's fitted coat that cuts away over the hips and descends in a pair of tapering skirts behind, usually black

TOPSTITCHING

Decorative stitching on the outside of a garment. Topstitching usually runs parallel to a seam

VAMBRACE

A piece of plate armor for the forearm

WALE

The texture or weave of a fabric

WAISTCOAT

An ornamental vest worn under a doublet

WARP

The threads that run lengthwise on a loom or in a woven fabric

WEFT

The threads that run from side to side on a loom or in a woven fabric

FLATS & CROQUIS

There are two types of fashion illustrations: *flats* and *croquis. Croquis* means "sketch" in French.

FLATS

A flat is a basic, symmetrical illustration that focuses on the details of the garment. This can be a hand-drawn flat (with the shape of a body, if preferred) or a technical flat, which is sent to manufacturers to explain specs for production.

CROQUIS

A croquis [kroh-kee] is a stylized illustration of a design. The garment is depicted on a model. A croquis can have elements of a flat (as demonstrated by the illustrations throughout this book), or it can be highly stylized, such as a painted illustration with movement.

For ease of reproduction, it's generally a good idea to design a few templates to use in your work. Whether you are using a light table and drawing by hand or illustrating with graphics software, templates will serve to both speed up your process and give you a recognizable style. You'll find basic female and male croquis templates on pages 126 and 127 to help you get started!

FIGURE PROPORTIONS

In traditional figure drawing, the human body is rendered in proportion. That is, the arms, hands, legs, feet, and torso are always drawn relative to each other in terms of size and space. The average adult body is seven to eight heads tall. In fashion illustration, however, artistic license may be taken to better serve the representation of the clothes being drawn. Fashion figure illustrations often have extraordinarily long legs, tiny waists, and wide-set shoulders. Many designers adopt their own sketching style. Use the proportions shown here as a guideline, but feel free to exaggerate or change them as you see fit. You are the designer—follow your own unique vision!

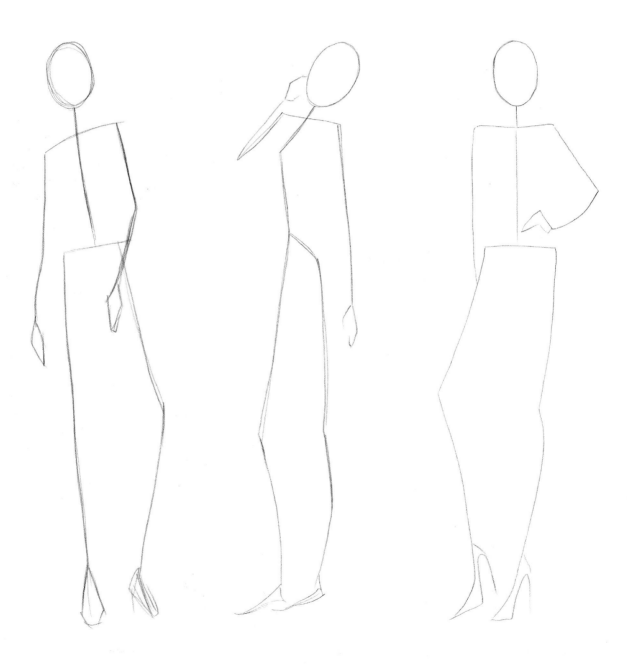

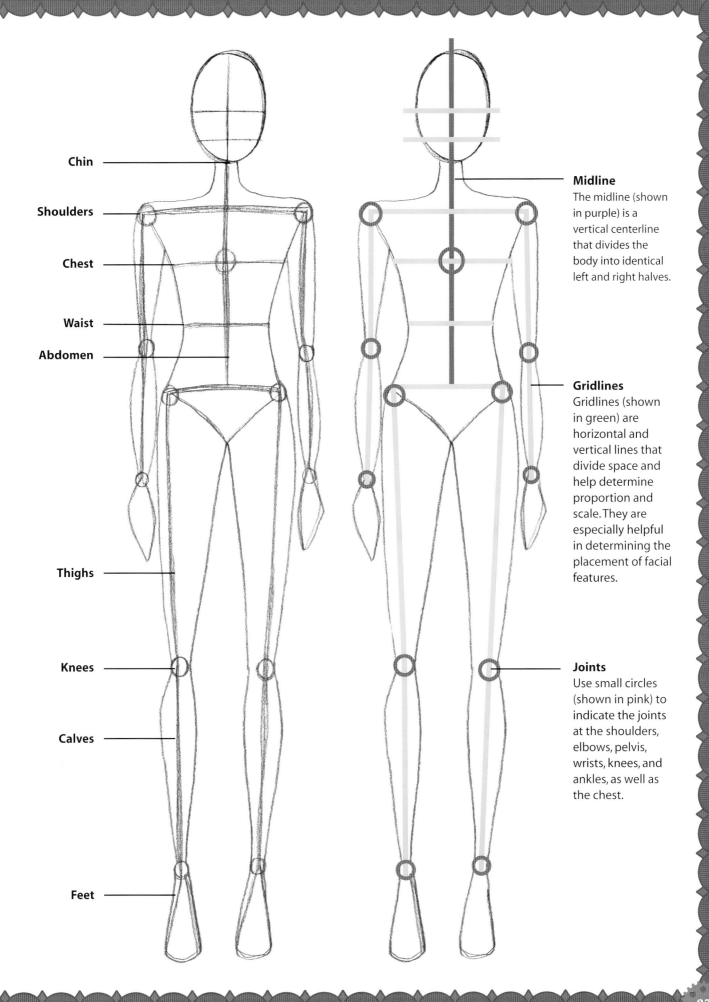

Chin

Shoulders

Chest

Waist

Abdomen

Thighs

Knees

Calves

Feet

Midline
The midline (shown in purple) is a vertical centerline that divides the body into identical left and right halves.

Gridlines
Gridlines (shown in green) are horizontal and vertical lines that divide space and help determine proportion and scale. They are especially helpful in determining the placement of facial features.

Joints
Use small circles (shown in pink) to indicate the joints at the shoulders, elbows, pelvis, wrists, knees, and ankles, as well as the chest.

FABRIC TYPES

THE FOLLOWING FABRICS are great for Steampunk, Lolita, and Neo-Victorian fashions. Before you begin, accumulate a collection of labeled fabric swatches so you know how they function in each type of design.

ALENÇON
A delicate needlepoint lace

ANGORA
A soft yarn or wool made from the hair of the Angora goat or rabbit

ANTIQUE SATIN
A reversible satin-weave fabric usually made with a blend of fibers

BARK CLOTH
Textured, woven fabric often used for upholstery and bedcovers

BATISTE
A lightweight, plain, often-sheer fabric usually made of cotton or cotton blends

BATISTE

BATTENBERG LACE
A Renaissance lace

BOILED WOOL
A felted, knitted wool that offers the flexibility of a knit with great warmth

Boiled wool is a great choice for jackets and vests!

BOUCLÉ
A knit of woven fabric with small curls or loops that create a nubby surface

BOUCLÉ

BROADCLOTH
A plain-weave, tightly woven fabric usually made of cotton or a cotton blend

BROCADE
A heavy fabric woven with an elaborate design and a raised overall pattern

BROCADE

BRODERIE ANGLAISE
Fine white needlework done on fine cloth, typically eyelet

CALICO
A tightly woven cotton fabric with an overall print, usually a small floral pattern, on a contrasting background color

CAMEL'S HAIR
A soft, natural fiber obtained from the underhair of the camel; similar to cashmere

Camel's hair is appropriate for coats and jackets!

CANVAS

A strong, durable, closely woven cotton fabric

CANVAS

CASHMERE

A natural fiber obtained from the soft, fleecy undergrowth of the Kashmir goat

CHAMBRAY

A plain, woven fabric commonly made from cotton that incorporates a colored warp (often blue) and white filling yarns

CHAMBRAY

CHANTILLY LACE

A delicate silk, linen, or synthetic bobbin lace that is scalloped along one edge and often has outlined designs of scrolls, vases, or baskets of flowers

CHARMEUSE

A supple, silky fabric with a shiny satin face and a dull back

CHARMEUSE

Charmeuse is great for blouses, fuller pants, and lingerie!

CHIFFON

A sheer fabric of silk, nylon, or rayon in plain weave

CHIFFON

CHINTZ

A printed cotton fabric, glazed or unglazed

CHINTZ

CORDUROY

A cotton-filling pile fabric with lengthwise cords or ridges

CORDUROY

COTTON

A white vegetable fiber grown in warmer climates used to produce many types of fabrics

COTTON

COTTON DUCK

A heavy, plain-weave cotton fabric

COUTIL

A sturdy fabric constructed of compactly woven herringbone twill

CRÊPE

A lightweight fabric of silk, cotton, or other fiber with a finely crinkled or ridged surface

CRÊPE-BACK SATIN

A satin fabric in which highly twisted yarns are used in the filling direction

CRÊPE DE CHINE

A light, soft silk or synthetic fabric with minute irregularities of surface

Crêpe de Chine is best for trousers and jackets.

CRINOLINE

A stiff, coarse cotton material for interlining

CRUSHED VELVET

Velvet processed to have an uneven, slightly wrinkled surface

DAMASK

A reversible fabric of linen, silk, cotton, or wool woven with patterns

DENIM

A twill-weave cotton fabric made with different colored yarns in the warp and the weft

DENIM

DUPIONI SILK

A crisp fabric with irregular slubs

Dupioni silk is perfect for tailored, slimmer silhouettes.

DUPIONI SILK

EGYPTIAN COTTON

A variety of cotton with silky, strong fibers grown chiefly in northern Africa

FAUX FUR

Artificial fur made from synthetic material

FELT

A non-woven fabric made from wool, hair, or fur matted together by heat, moisture, and great pressure

FISHNET

A fabric having an open mesh resembling a fishnet

FLANNEL

Typically a 100-percent cotton fabric that has been brushed on one or both sides for softness

FLANNEL

GABARDINE

A firm, tightly woven fabric of worsted cotton, polyester, or other fiber with a twill weave

GAUZE

A sheer, open-weave fabric; usually cotton or silk

Gauze is suitable for blouses and dresses.

GEORGETTE

A sheer silk or rayon crêpe of dull texture

Georgette is drapey and suitable for blouses, full pants, and flowing dresses.

GINGHAM

A medium-weight, plain-weave fabric with a plaid or check pattern

GINGHAM

GROSGRAIN

A heavy, corded cloth of silk or rayon

HARRIS TWEED

A brand of heavy, handwoven woolen fabric made in the Outer Hebrides off the coast of Scotland

HERRINGBONE

A variation on the twill-weave construction in which the twill is reversed (or broken) at regular intervals, producing a zigzag effect

HERRINGBONE

HOUNDSTOOTH

Woven or printed with a pattern of broken or jagged checks

HOUNDSTOOTH

JACQUARD

A fabric with an elaborately woven pattern produced on a Jacquard loom

JERSEY FABRIC

A thin, lightweight knit fabric

JUTE

A bast fiber, chiefly from India, used primarily for gunny sacks, bags, and cordage

KHAKI

A tan-or dusty-colored fabric made of cotton, linen, wool, worsted, or man-made fibers and blends

KHAKI

LACE

An openwork fabric with yarns that are twisted around each other to form complex patterns or figures

LACE

LAWN

A light, fine cloth made of carded or combed linen or cotton yarns

LEATHER

Animal skin dressed for use in clothing

LEATHERETTE

Constructed cloth finished to simulate the grain, color, and texture of leather

LINEN

Fabric woven from flax yarns, which are stronger and more lustrous than cotton

LINEN

MICROFIBER

A very fine polyester fiber that can be woven into textiles with the texture and drape of natural-fiber cloth, but with enhanced washability, breathability, and water repellency

MOHAIR

Hair fibers from the Angora goat

MOIRÉ

A fabric, usually silk, with a watered or wavelike pattern

MOIRÉ

MOLESKIN

A strong, heavy, twilled cotton fabric that resists wrinkling and has a sueded look on the face

Moleskin is great for pants, jackets, and heavy shirts.

MUSLIN

A medium-weight, plain-weave, low-count cotton sheeting fabric

NEOPRENE

An oil-resistant synthetic rubber

ORGANDY

A stiffened, sheer, lightweight, plain-weave fabric, usually cotton or polyester

ORGANZA

A crisp, sheer, lightweight, plain-weave fabric with a medium-to-high yarn count; made of silk, rayon, nylon, or polyester

ORGANZA

PIQUÉ

A medium-weight cotton or cotton-fabric blend with a pebbly weave similar to a check

Piqué is suitable for vests, jackets, and fitted blouses.

POPLIN

A finely corded fabric of cotton, rayon, silk, or wool

POPLIN

RASCHEL KNIT

A warp-knitted fabric that is somewhat coarse and contains openwork patterns

RAYON

A natural fiber created from wood pulp

RAW SILK

A reeled silk that has not had the gum removed

SATEEN

A strong cotton fabric with a lustrous face; constructed in satin weave

SATEEN

SEERSUCKER

A fabric with a woven pucker; traditionally cotton

SEERSUCKER

SHANTUNG

A heavy silk fabric with a knobby surface

SHARKSKIN

A smooth fabric of acetate or rayon with a dull or chalklike appearance

SUEDE

Leather with a napped surface

SUEDE

TAFFETA

A medium- or lightweight fabric of acetate, nylon, rayon, or silk; usually smooth, crisp, and lustrous with a fine, crosswise rib effect

TAFFETA

TAPESTRY

A fabric consisting of a warp upon which colored threads are woven by hand to produce a design, often pictorial

TOILE

A type of decorating pattern consisting of a solid background on which a repeated pattern depicts a single-color scene, usually black, dark red, or blue

TOILE

TRICOT KNIT

A plain, warp-knitted fabric with a close, inelastic knit

TWEED

A medium- to heavyweight, woolen, twill-weave fabric containing colored slubbed yarns

TWILL

A fabric that shows a distinct diagonal wale on the face

TWILL

VELOUR

A velvetlike fabric of rayon, wool, or other natural or synthetic fiber

VELVET

A fabric of silk, nylon, acetate, or rayon (sometimes with a cotton backing) with a thick, soft pile formed by loops of the warp thread

VELVET

VELVETEEN

A cotton or cotton-blended fabric with a short, dense pile

VOILE

A crisp, lightweight, plain-weave, cottonlike fabric similar in appearance to organdy and organza

WORSTED

A smooth, compact yarn from long wool fibers

WOOL

From the soft, thick hair of sheep (and some other animals)

WOOL

Fabric choice is a key element for any design. Build a collection of fabric samples you can refer to when designing outfits and costumes. Experiment with various fabrics to learn how they will or won't work for certain types of clothing or sewing techniques. Some fabrics won't work for certain projects. For example, chiffon is not sturdy enough for a corset, and jersey knit has too much stretch for a suit jacket.

CREATING TEXTURE

NOW THAT YOU'RE FAMILIAR with some fabric options, you can start practicing how to create an assortment of textures in your designs.

Plaid Use marker for the base color. Add vertical and horizontal lines with colored pencil in groups of three, alternating between colors.

Tweed Use marker for the base color, followed by crosshatching all over, alternating pencil colors. The key to this texture is adding lots of layers. Finish with a bit of white gel pen or a fine-tipped pigment ink pen to add definition.

Sparkles/Sequins Use marker for the base color. Then add lots of dots and circles using fine-tipped pigment ink pens and gel pens in black, white, and coordinating colors. Use a white gel pen to add stars and bursts for twinkle.

Netting/Tulle Choose two or three analogous shades of colored pencil, and create a diagonal crosshatched pattern. Keeping your pencils sharp will help create a more delicate-looking texture.

Denim Start with a muted gray-green marker for the base color. Use colored pencils to add light crosshatching over the area in several different shades of blue and gray. Keep your pencil sharp so that you can still make out the crosshatching, which reads as a "woven" texture.

Shiny (patent leather, satin, etc.) Creating a shiny texture is all about contrast. Lay down a bold color using marker, leaving some white areas of varying widths as you move across the paper. Then add a few vertical stripes of a slightly darker shade.

Layered Chiffon Use a light-colored marker for the base. Gradually build up shading in a vertical pattern using analogous shades of colored pencil. Darken the areas around the gathers slightly, and finish with a white colored pencil to highlight the lightest areas in the folds.

Polka Dots Use marker for the base color. Then create an even pattern of circles with colored pencil. Use an index card or ruler to help keep the rows straight.

Lace White lace can be indicated with light colors. Sketch the pattern, and then accent each shape with other light colors, such as cream, light yellow, and blue-gray colored pencils.

Appliqué Use the same principles for creating a lace texture. Keep in mind that appliqués fill only a particular space—they are not all-over patterns.

Topstitching Use marker for the base color. Then draw the seam lines with pencil. Shade along the seams with a colored pencil in a shade or two darker than your background color. Finish by drawing solid and dotted lines along the seam lines to indicate machine stitching.

Print Fabric Use marker for the base color. Then use colored pencil or marker to create a specific pattern, such as cherries or flowers. Use an index card or ruler to help keep the rows straight.

Gathered Hemline Draw a wavy line where a straight hemline would be. To show the gathers, draw a short, straight vertical line from each wavy fold up into the garment, allowing the lines to fade off. Color the inside folds along the hemline a shade darker than the primary color of the fabric. Then, using a light hand, shade the vertical folds with a slightly darker, analogous pencil color.

Pleated Hemline To create a pleated hemline, draw a jagged horizontal line where a straight hemline would be. To show the pleats, draw a short, straight vertical line from each corner of the jagged line up into the garment, allowing the lines to fade off. Using a light hand, shade the vertical recessed folds a shade darker than the primary color of the fabric.

Gathers and Ruffles Use marker for the base color. Draw ruffled "lettuce" edges horizontally; then draw a series of loops and curved lines to show where the fabric is gathered just below the edge. Shade the areas closest to the gathered edge in the darkest color, tapering out to lighter areas. Repeat this technique for each ruffled tier.

Textures can be created in a variety of ways, using all sorts of drawing tools and techniques. Use these examples as a guide and explore creating textures with the materials you have on hand. You may be surprised by what you discover!

FABRIC TECHNIQUES
& DETAILS

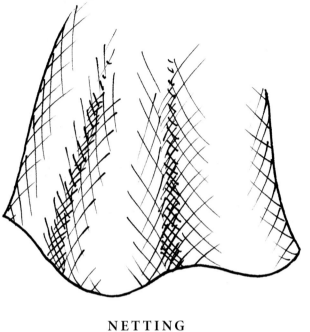

NETTING

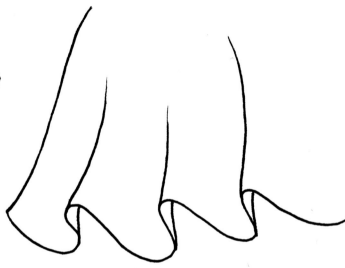

LOOSE PLEATS

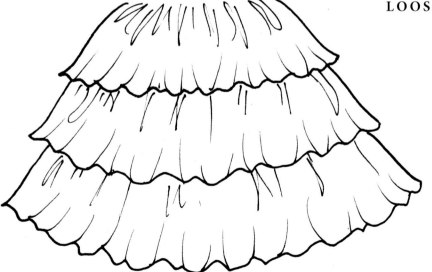

FLOWING RUFFLES

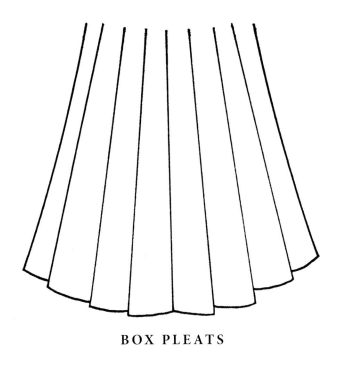

BOX PLEATS

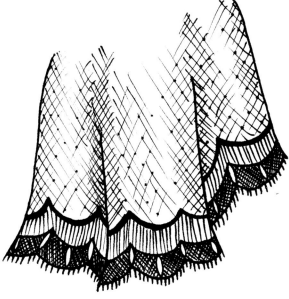

LACE

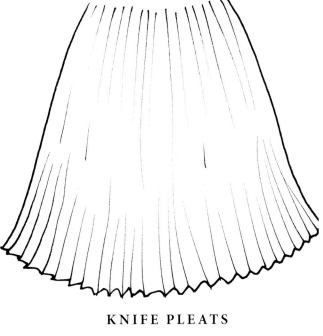

KNIFE PLEATS

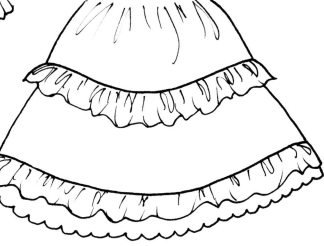

RUFFLES

SKIRT LENGTHS

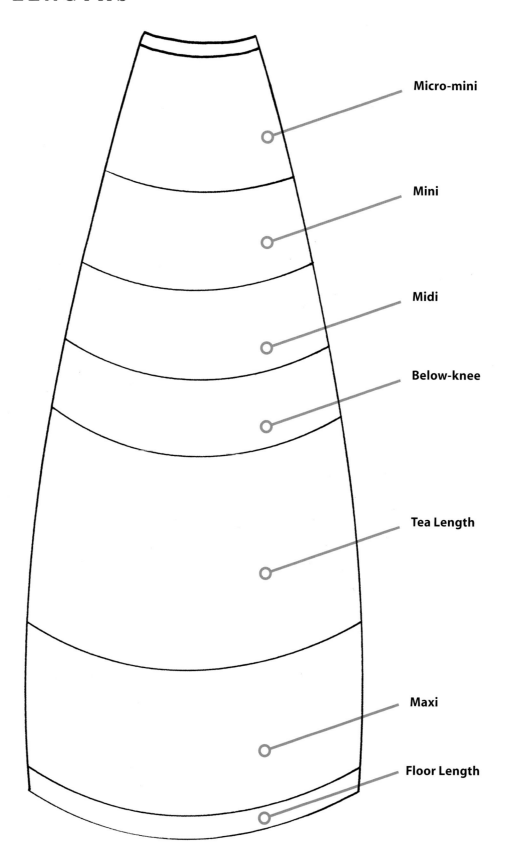

Micro-mini

Mini

Midi

Below-knee

Tea Length

Maxi

Floor Length

SKIRT TYPES

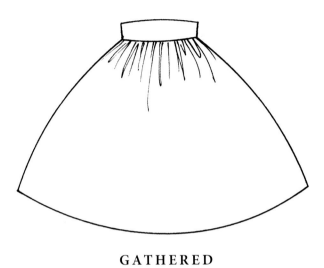

GATHERED

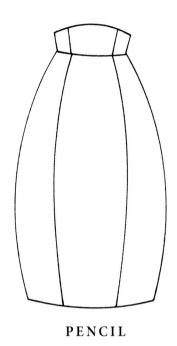

PENCIL

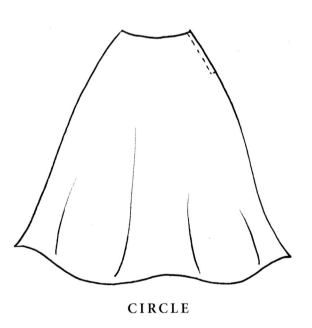

CIRCLE

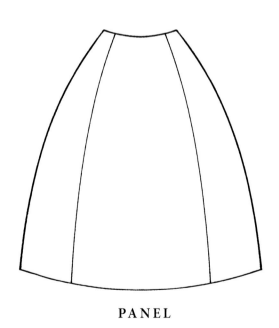

PANEL

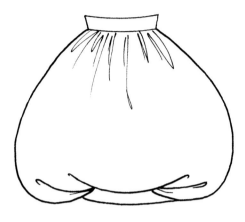

BUBBLE

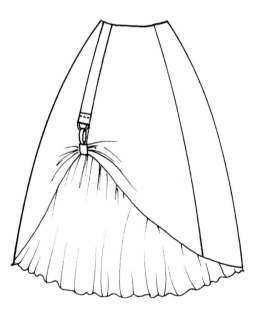

FRONT PICKUP

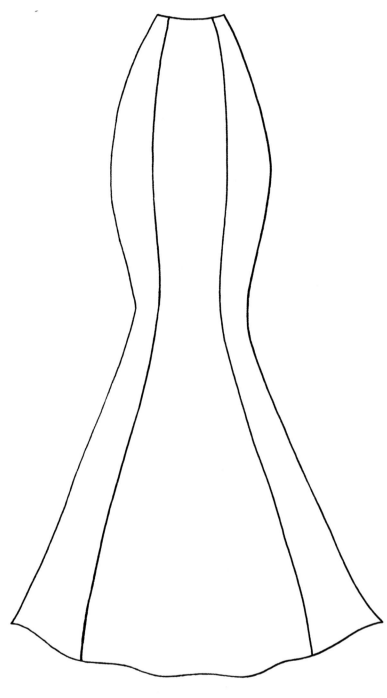

MERMAID

WOMEN'S NECKLINES

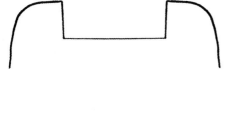

SQUARE
A square neckline draws attention to the face and elongates the upper body.

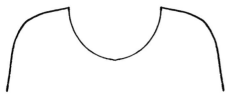

SCOOP
A scoop neckline is a good fit for most body types.

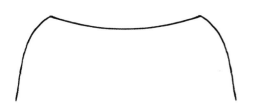

BOAT
Also called a "bateau" neckline, this substantial neckline draws the eye to the shoulders and creates the illusion of square shoulders, a shorter neck, a fuller face, and a more ample bust.

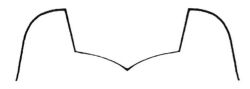

SWEETHEART
A sweetheart neckline creates the illusion of curves and shows off the collarbone and décolletage.

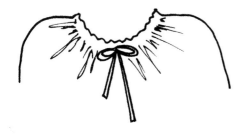

GATHERED
Also called a "drawstring," "peasant," or "gypsy" neckline, this full neckline can be adjusted or gathered with a drawstring cord or elastic.

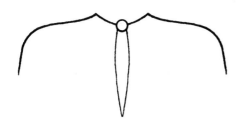

KEYHOLE
This high neckline has a round- or wedge-shaped opening cut out at the front.

WOMEN'S COLLAR TYPES

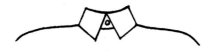

CLASSIC
This two-piece, high-stand collar may have square, round, or pointed collar ends. There are several variations on this type of collar.

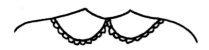

PETER PAN
A Peter Pan collar has rounded ends at the center front.

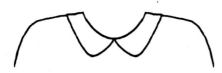

POINTED FLAT
This collar has long, pointed ends that scoop lower than normal collars.

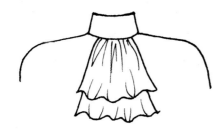

JABOT
A jabot collar consists of one or more straight ruffles attached to the neckline at the center front.

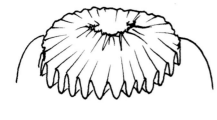

RUFF
This wide, pleated collar is often stiffened with starch or wire.

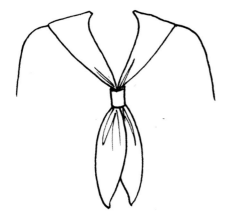

SAILOR
This broad collar has a square flap across the back and tapers to a "V" in the front.

MEN'S COLLAR TYPES

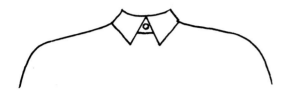

POINT
This traditional men's shirt collar is distinguishable by the small spread between the collar points.

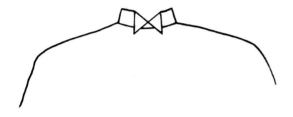

WING
The tips of this collar resemble wings, hence its name.

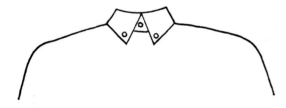

BUTTON-DOWN
This collar has two small buttons on the collar ends to keep it neat.

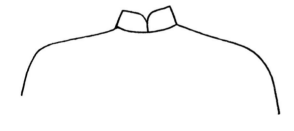

BAND
This collar style isn't much of a collar at all, but more of a neckband.

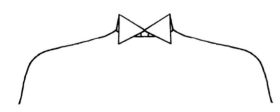

SPREAD
The collar points of this design create an approximate 45-degree angle.

WOMEN'S SLEEVE TYPES

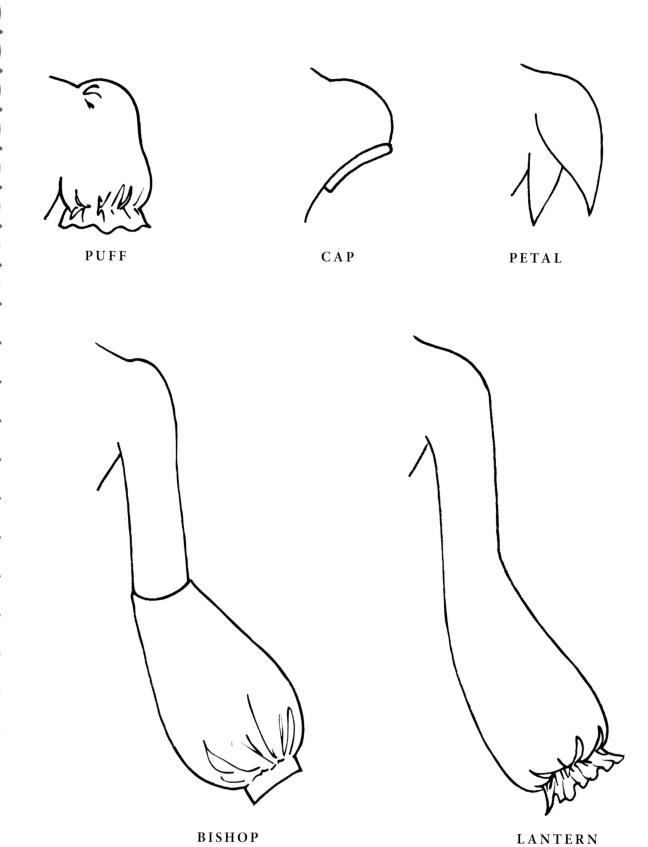

PUFF

CAP

PETAL

BISHOP

LANTERN

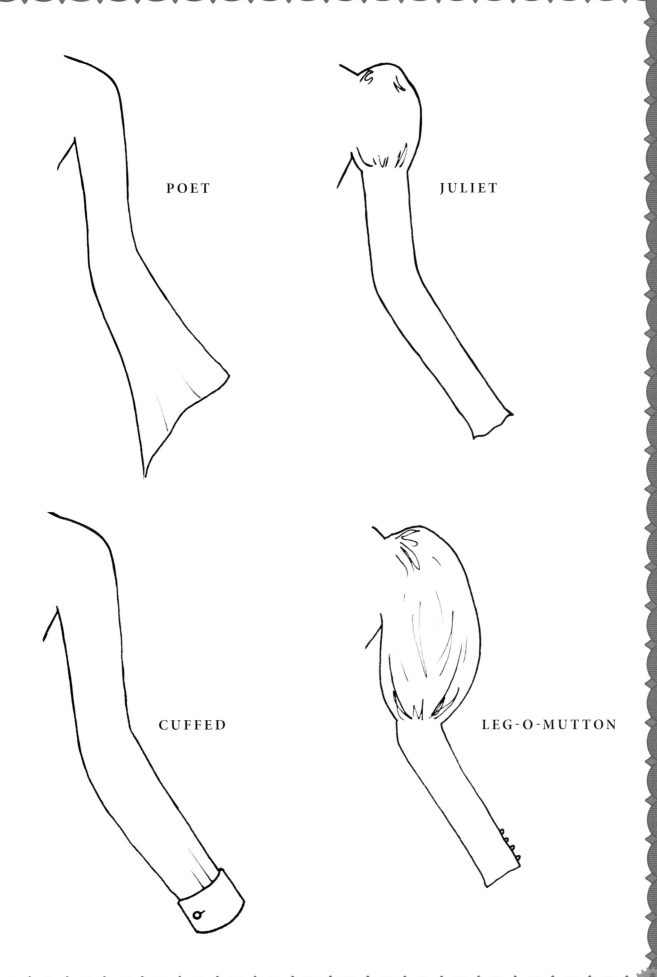

POET

JULIET

CUFFED

LEG-O-MUTTON

ILLUSTRATION PROJECTS

TURN THE PAGE to get started
on some Steampunk and Cosplay
fashion designs. You can use my examples
as inspiration for your own unique designs!

ARISTOCRAT

THE ARISTOCRAT comes from money, so she has high-quality garments with beautiful details. She is social and strives to be the talk of the town, but she also has responsibilities and needs to maintain an excellent professional reputation. The Aristocrat look should command a room.

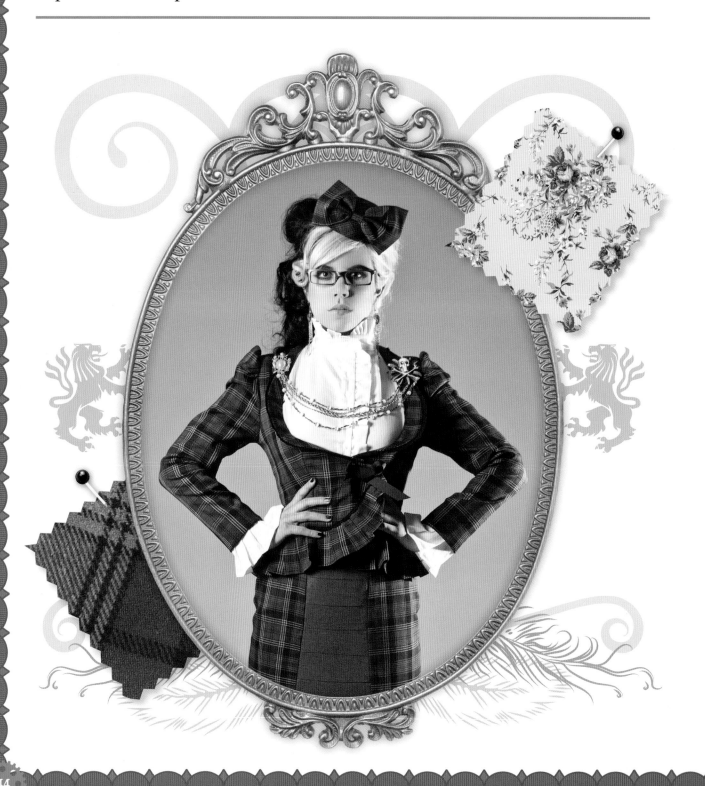

Start with an upright and elegant croquis.

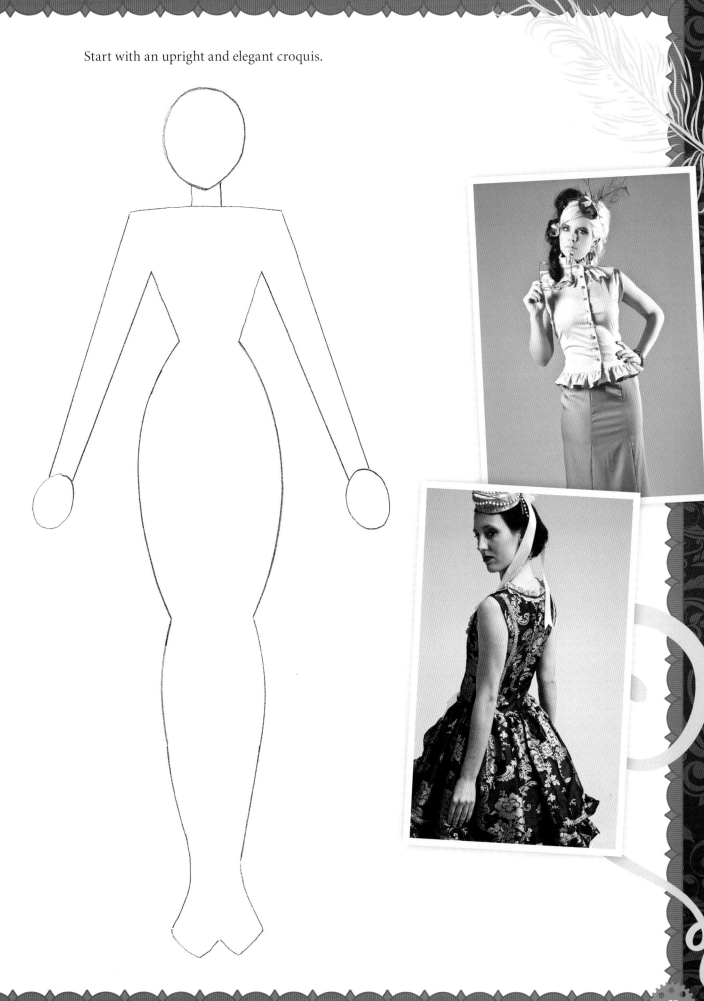

Add the outline of the outfit.

The female aristocrat wears a beautiful corset under or over her clothes.

Billowing skirts in sumptuous fabrics are a must for a formal aristocratic look.

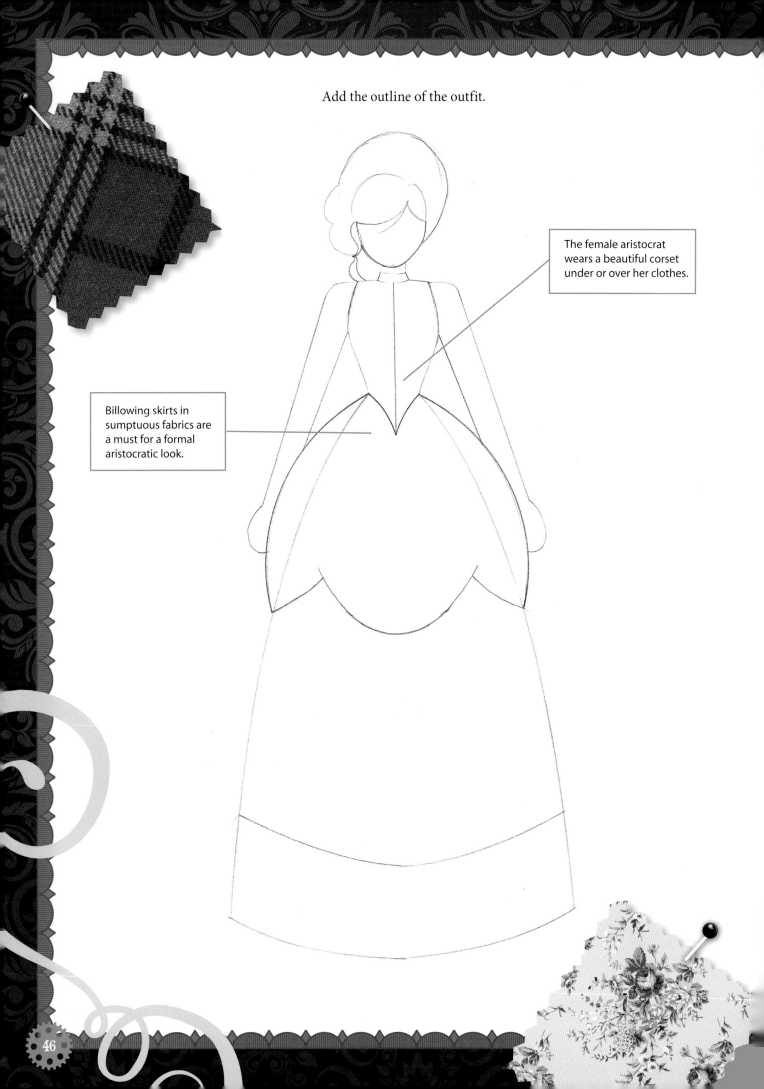

Then begin to add details.

Pile the hair high on the head, with some pieces hanging down, for a dramatic and refined look.

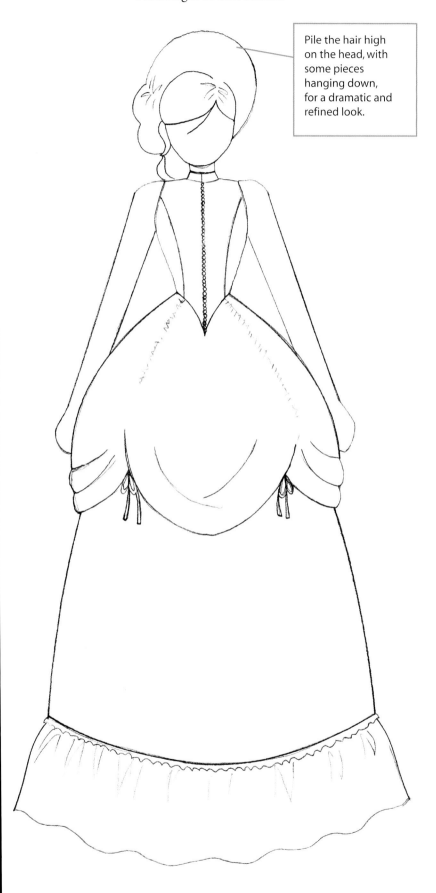

BODICE & SKIRT IDEAS

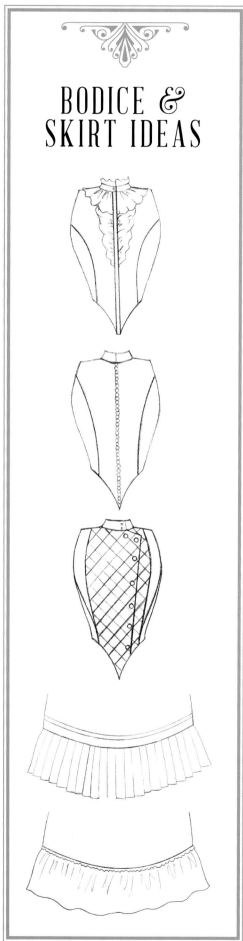

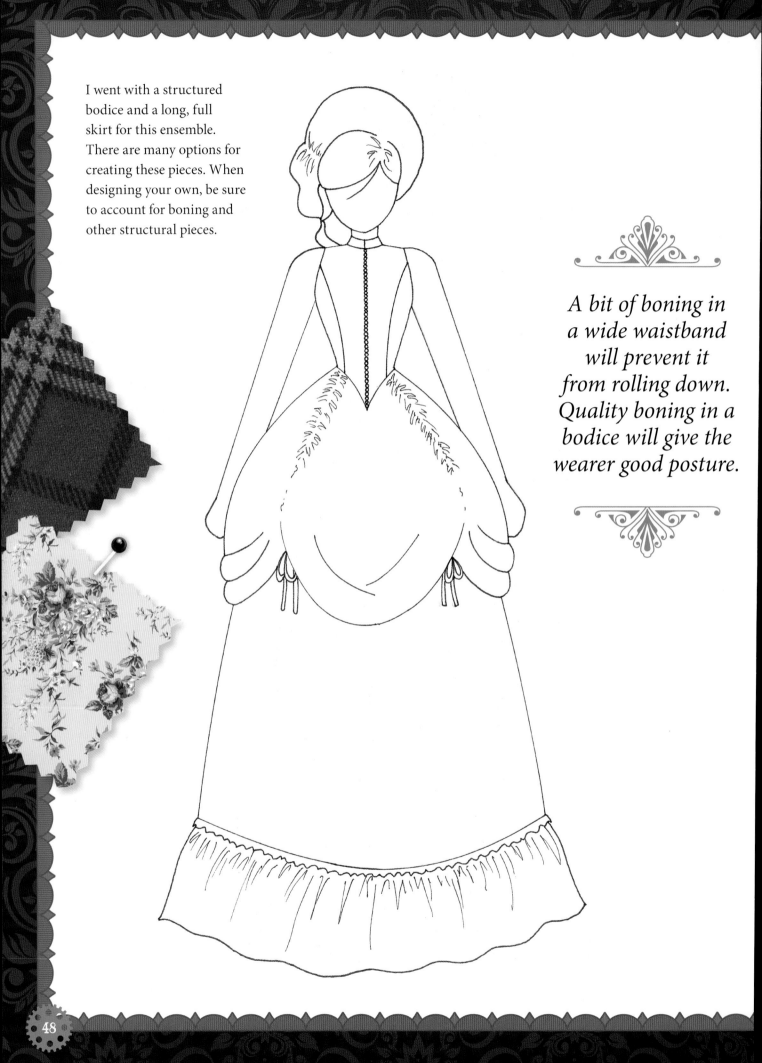

I went with a structured bodice and a long, full skirt for this ensemble. There are many options for creating these pieces. When designing your own, be sure to account for boning and other structural pieces.

A bit of boning in a wide waistband will prevent it from rolling down. Quality boning in a bodice will give the wearer good posture.

Finish the look with color, using the medium of your choice. I decided to keep the color simple. Shades of brown are seasonless, so this outfit could be worn anytime. The details in the bodice and the function of the skirt serve as the point of interest, rather than the color.

You can accessorize this look with a large or small hat, jewelry, shoes, Victorian gloves, and a parasol.

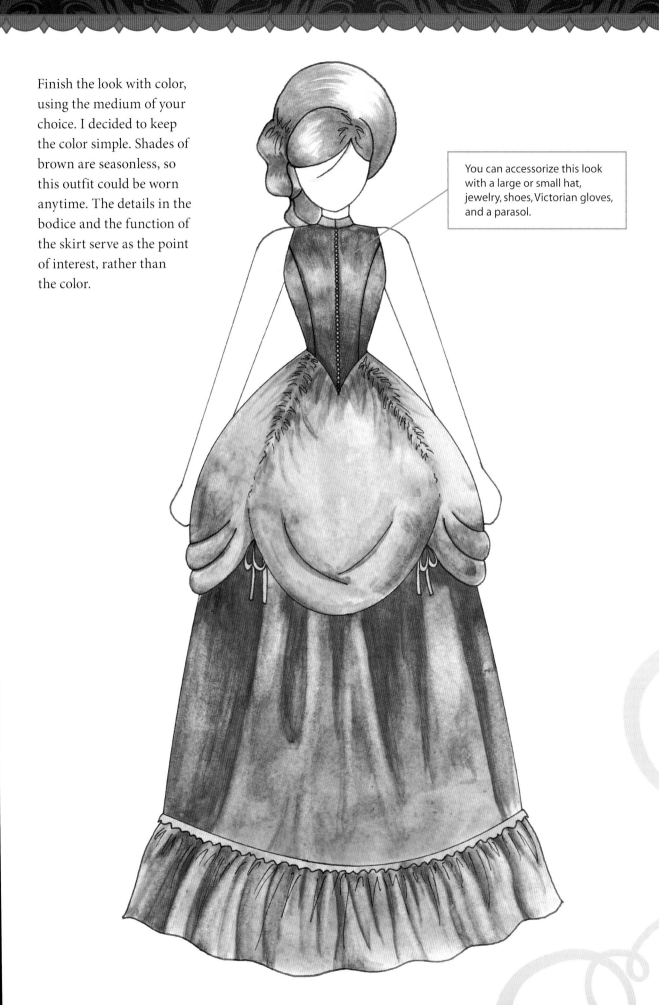

BLOOD RED

MAGENTA

ARISTOCRAT INSPIRATION GALLERY

MIDNIGHT

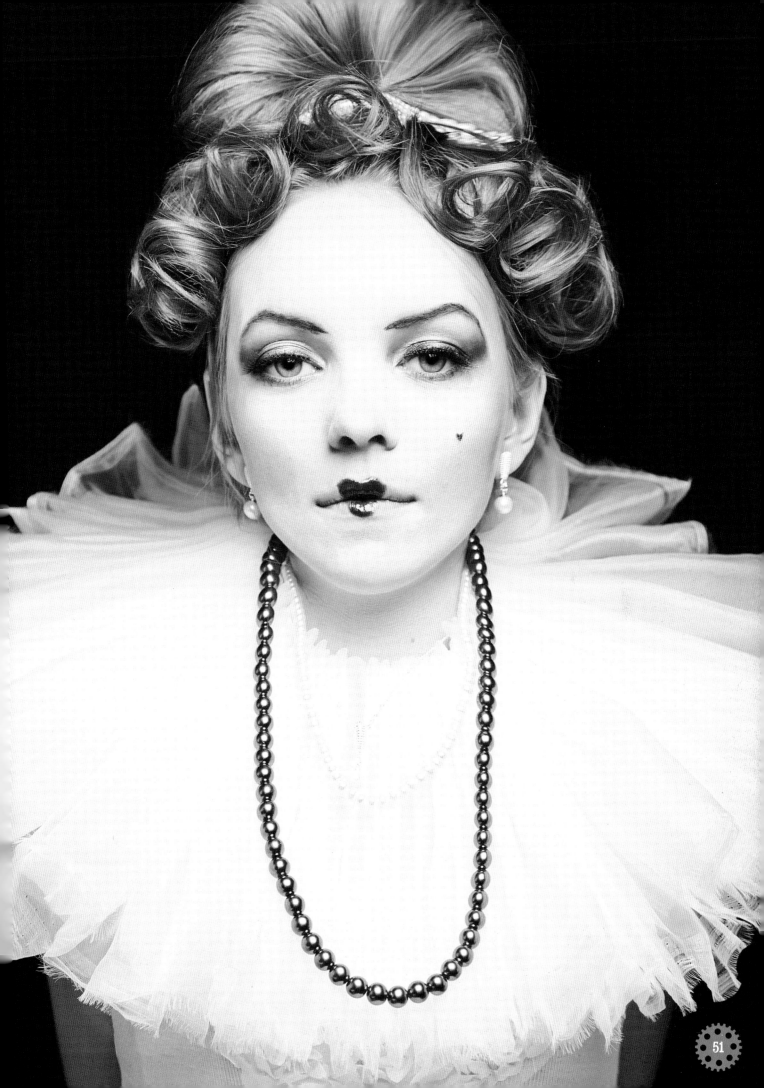

STREETWEAR

CASUAL STREETWEAR STEAMPUNK is a lot of fun! Similar to a casual Goth or Lolita look, this style takes the core aesthetic and "rules" of Steampunk fashion and generates pieces that can be worn in daily life.

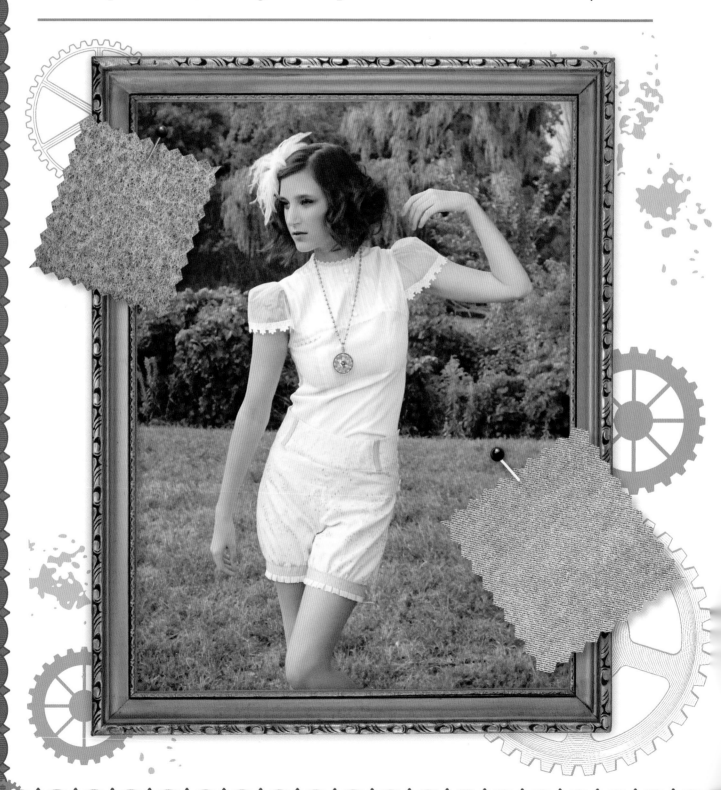

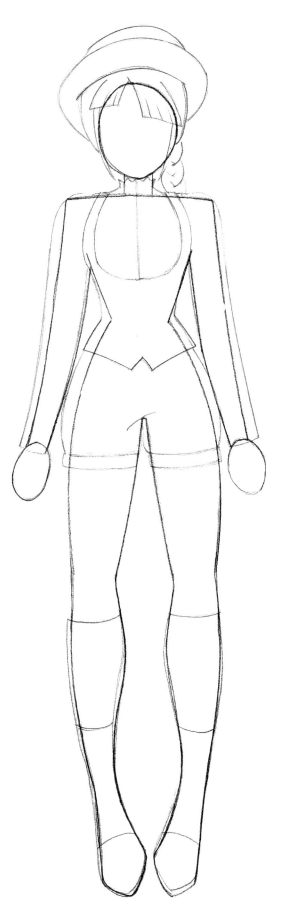

Sketch out your initial croquis, and then add the basic outline of the outfit. For this look I decided to go for a fun, summery ensemble—bloomers, a vest, and a blouse.

Separates are great for a casual look, and the pieces can be incorporated into other looks!

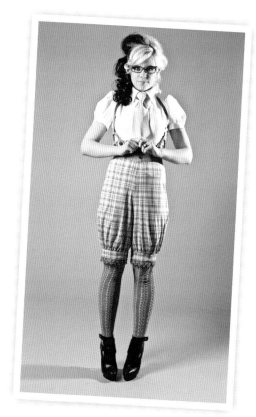

As you add details to the outfit, remember to keep it comfortable. Would the Streetwear model be able to go to work or shopping in this look? Could she comfortably wear it all day?

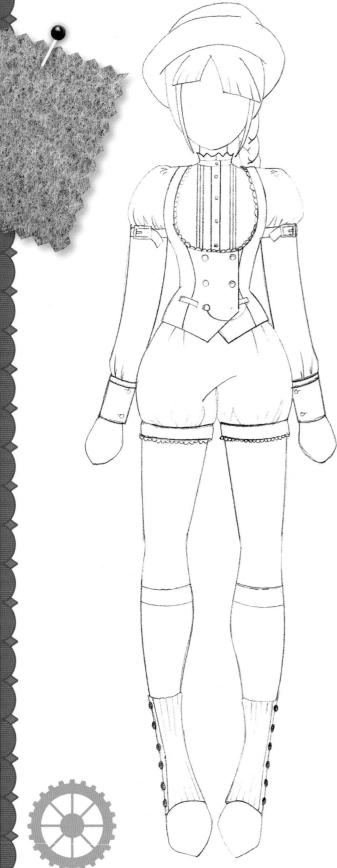

For a Streetwear look, add heavy detail to just one piece of the outfit. Otherwise the look will be overwhelming.

CASUAL VARIATIONS

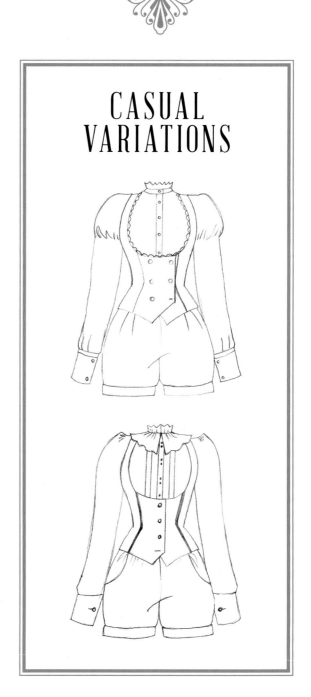

To finalize the look, give it a pop of color! I added a cute, summery straw hat and little spats to dress up any shoes the model will wear.

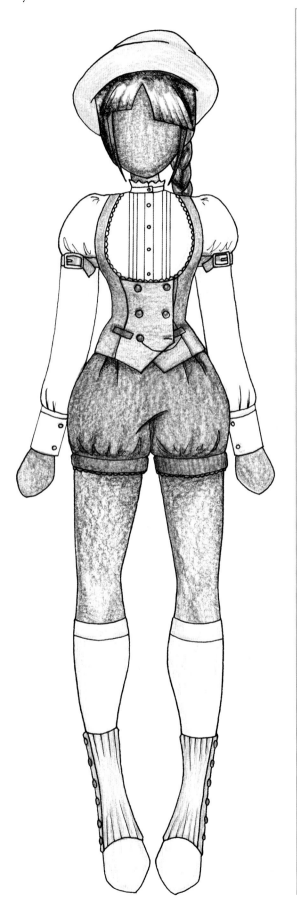

SELECTING FABRICS

As you finalize your design, consider fabric types. This is a summer look, so keep the blouse airy with a lightweight cotton or silk chiffon. The shorts would look and feel great in summer wool, chambray, or lightweight denim. The vest can be any type of fabric, but since summer is a bit more casual, avoid "dressier" fabrics such brocade. How about a thin-wale corduroy instead?

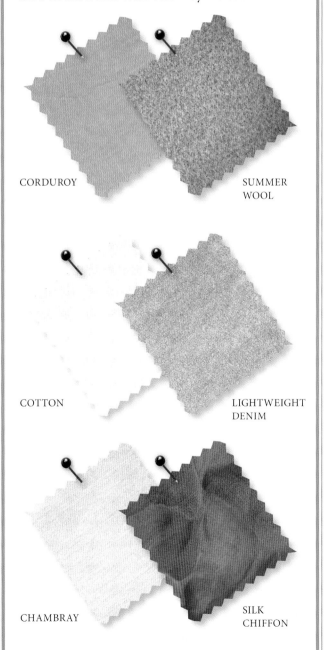

CORDUROY

SUMMER WOOL

COTTON

LIGHTWEIGHT DENIM

CHAMBRAY

SILK CHIFFON

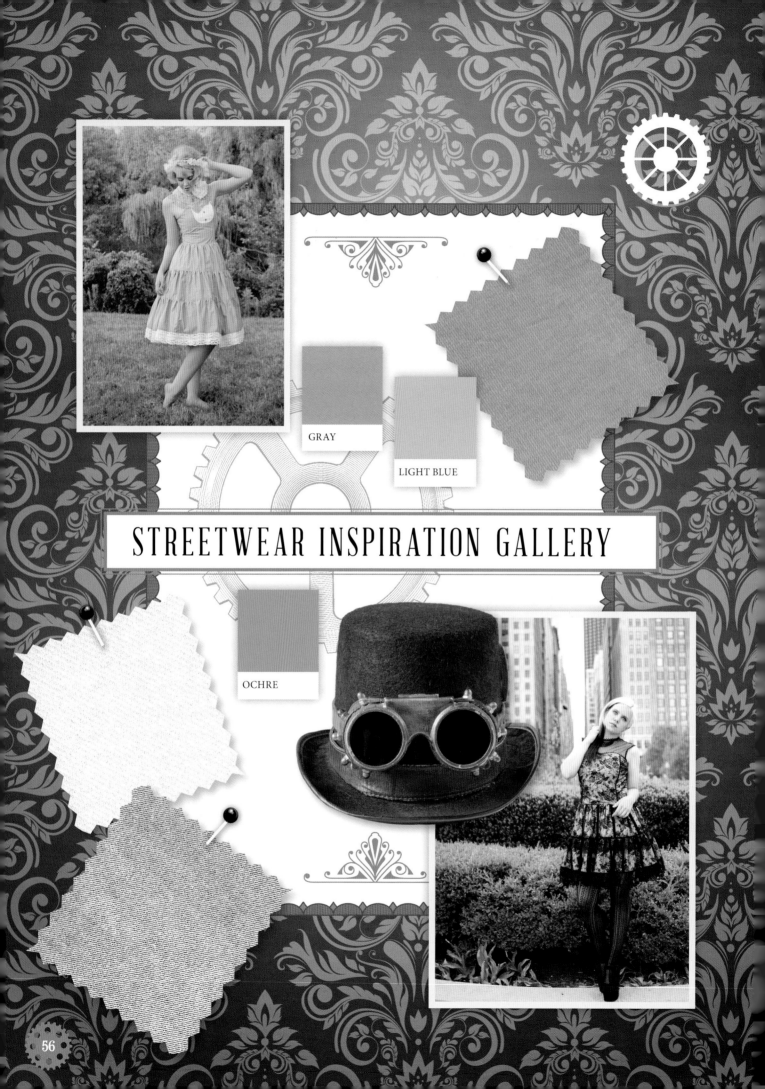

GRAY

LIGHT BLUE

STREETWEAR INSPIRATION GALLERY

OCHRE

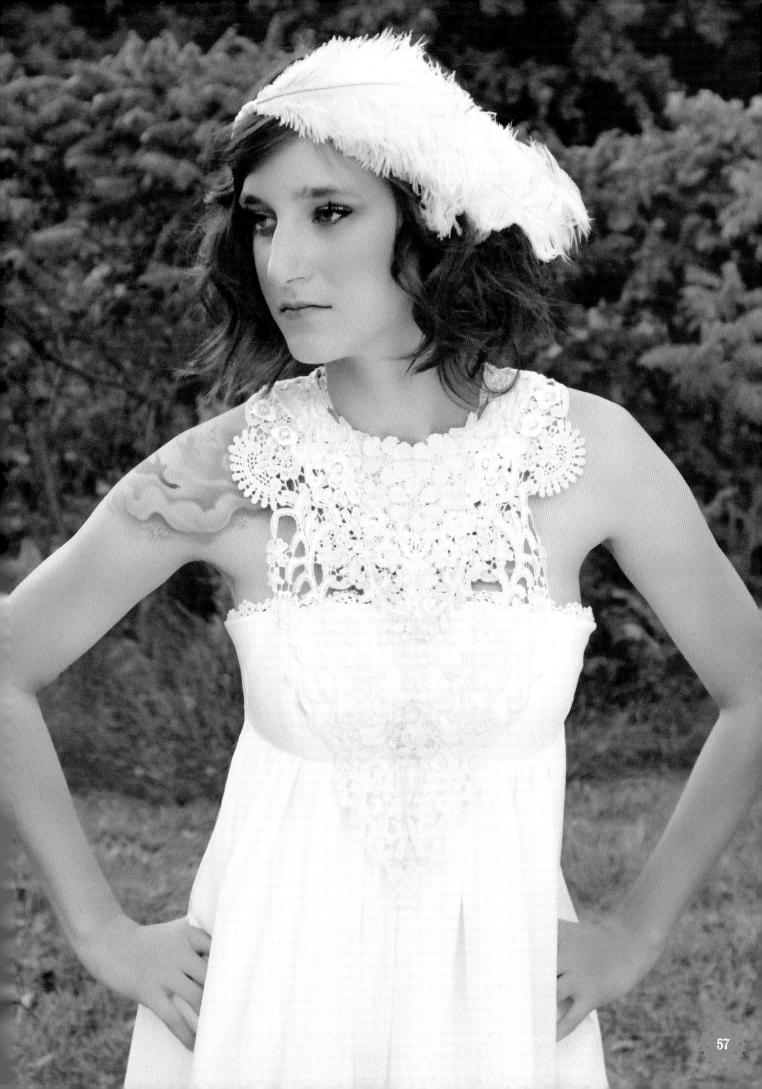

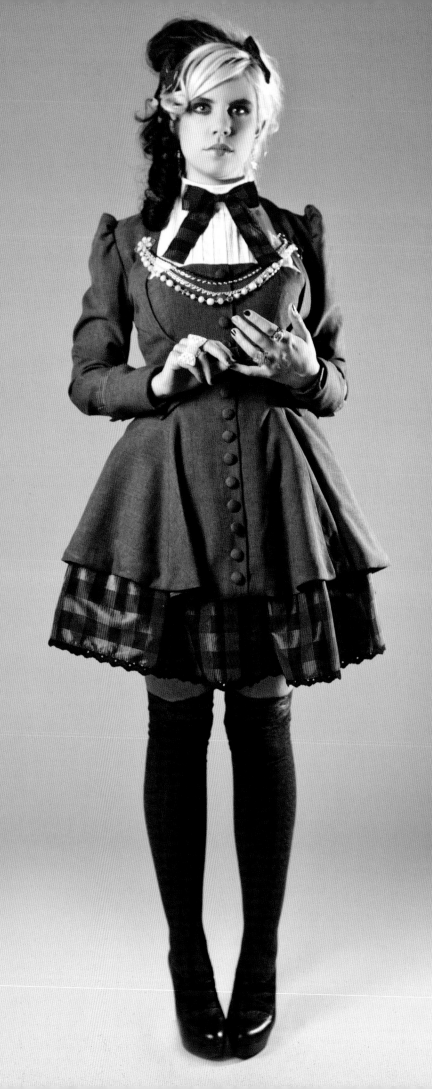

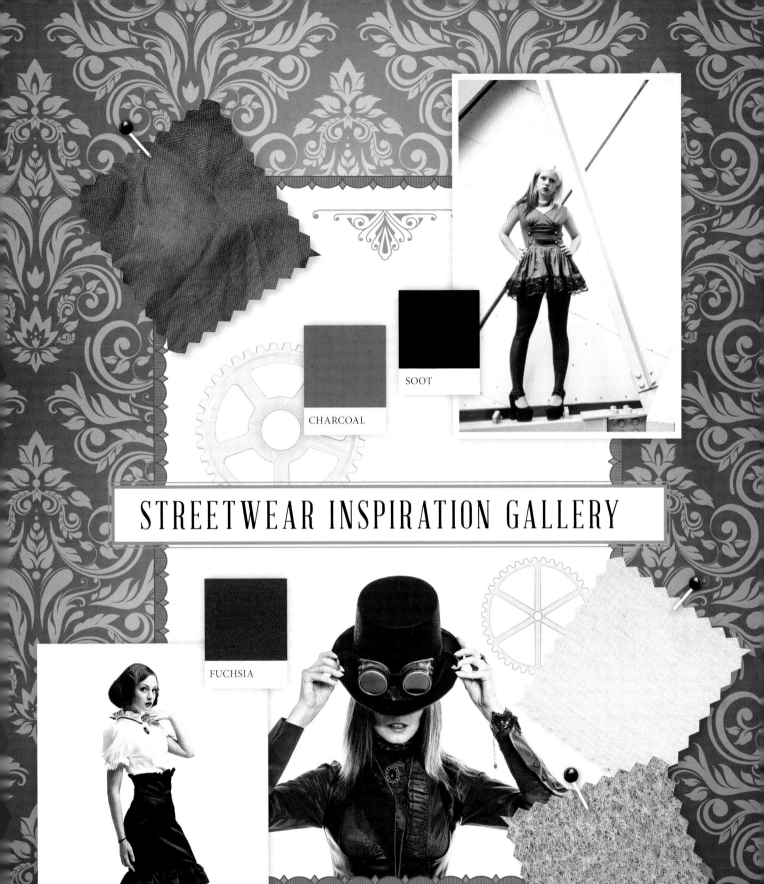

SOOT

CHARCOAL

STREETWEAR INSPIRATION GALLERY

FUCHSIA

DIESELPUNK

DIESELPUNK is generally portrayed as the time between the 1920s and the 1950s. It is gritty and powerful, influenced by war and work. More advanced in technology than Steampunk, the Dieselpunk look is more utilitarian. Dieselpunk formal wear is influenced by the Jazz Age and art deco.

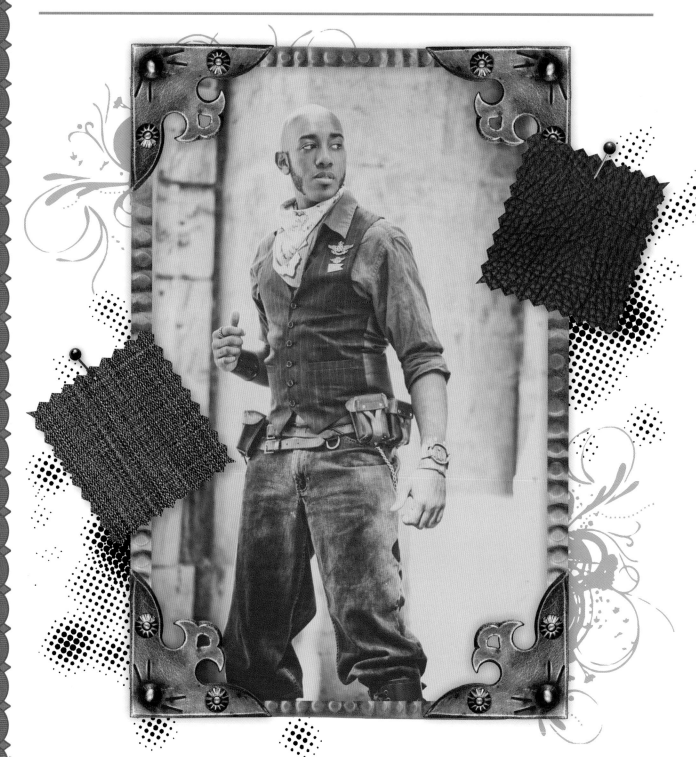

For this menswear look, start with a male croquis. Note the broadness of the shoulders.

I'm putting my Dieselpunk fellow in a button-down dress shirt, waistcoat, and slacks.

PLAYING WITH CLOSURES

This look allows you to experiment with closures. Menswear tends to be more subdued than womenswear. Fabric choices and closures will help make the look stand out.

ASYMMETRICAL BUTTONS

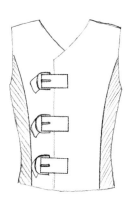

BUCKLES

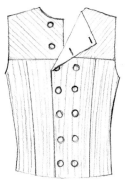

DOUBLE-ROW BUTTONS

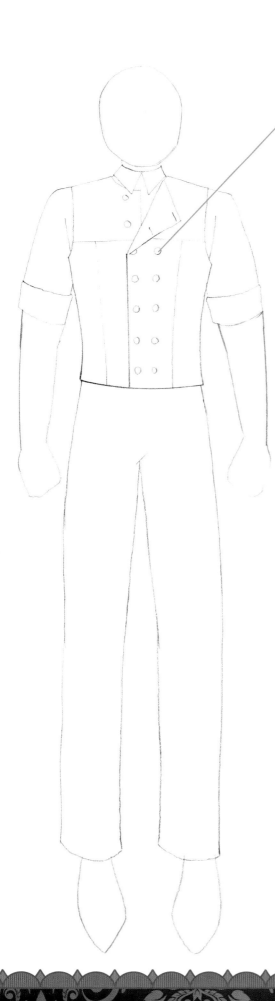

I decided to use a double row of buttons on the waistcoat.

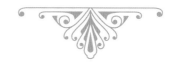

Remember that men's garments close left over right, while women's garments close right over left.

Now for the fun part—accessories! What does your Dieselpunk guy do? Is he a covert spy? A mechanic? Security detail? This decision is important when designing the accessories. The Dieselpunk model I'm designing this look for lives a life of action and adventure.

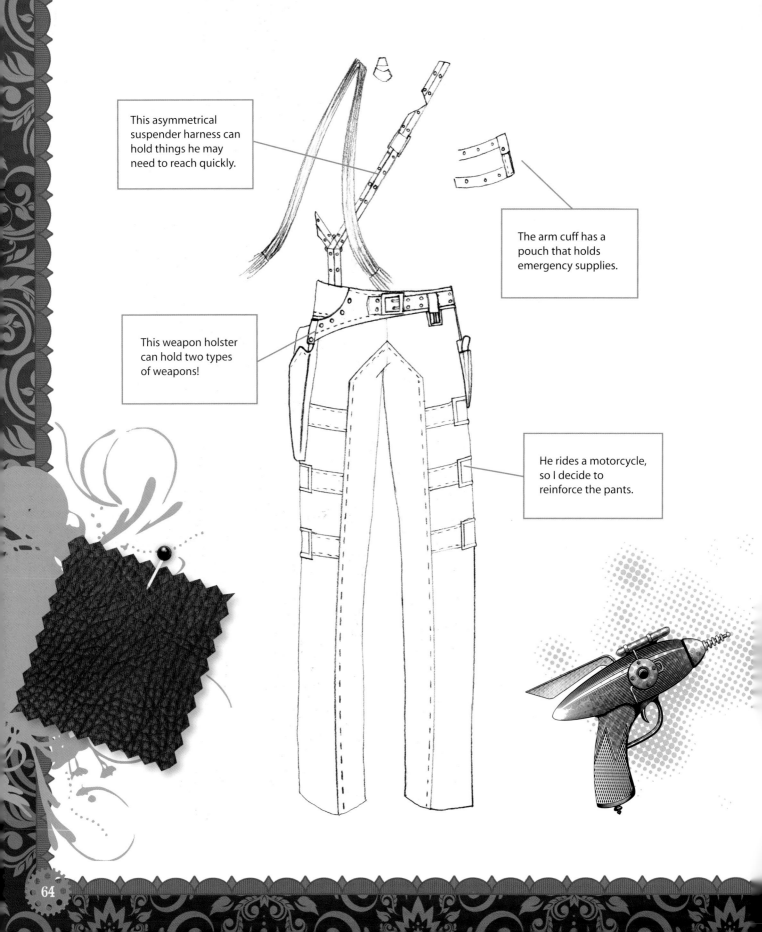

This asymmetrical suspender harness can hold things he may need to reach quickly.

The arm cuff has a pouch that holds emergency supplies.

This weapon holster can hold two types of weapons!

He rides a motorcycle, so I decide to reinforce the pants.

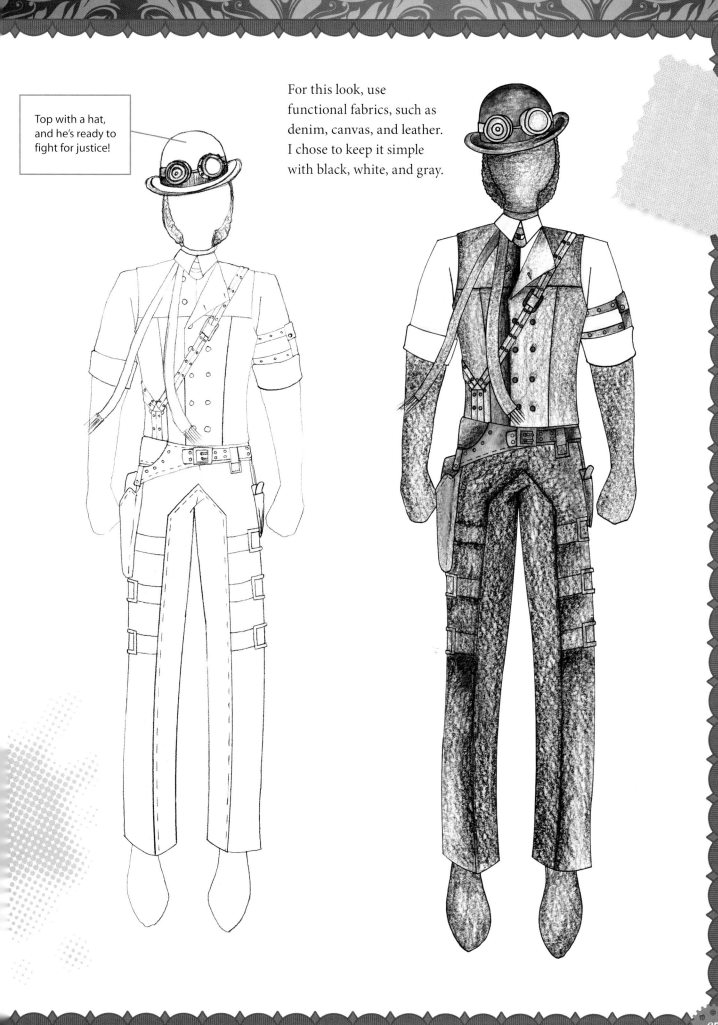

Top with a hat, and he's ready to fight for justice!

For this look, use functional fabrics, such as denim, canvas, and leather. I chose to keep it simple with black, white, and gray.

GREASE

DUST

INDIGO

DIESELPUNK INSPIRATION GALLERY

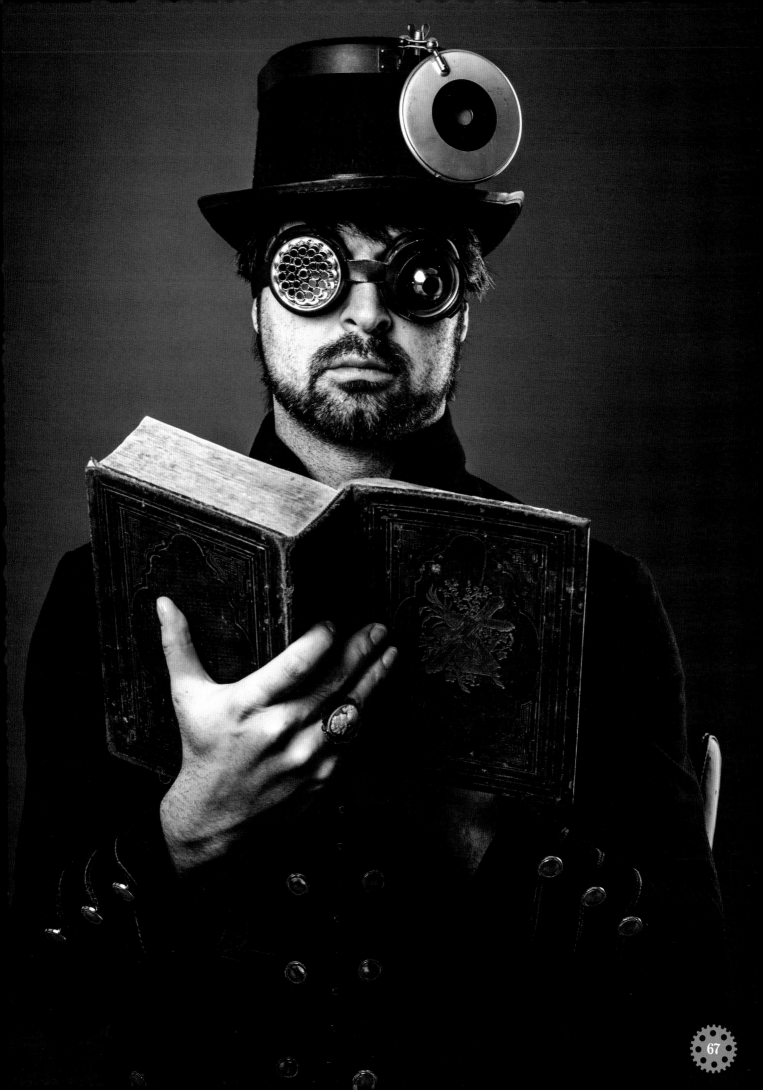

LOLITA

I WAS A LOLITA DESIGNER FOR 13 YEARS—this style is where my heart is. Lolita is a sweet, fun, and youthful style that originated in Japan decades ago and has since gained popularity worldwide. There are many, many subgenres to this style, and most people can find at least one that they can connect with. This look has much crossover with Steampunk, as they both have roots in the Victorian era.

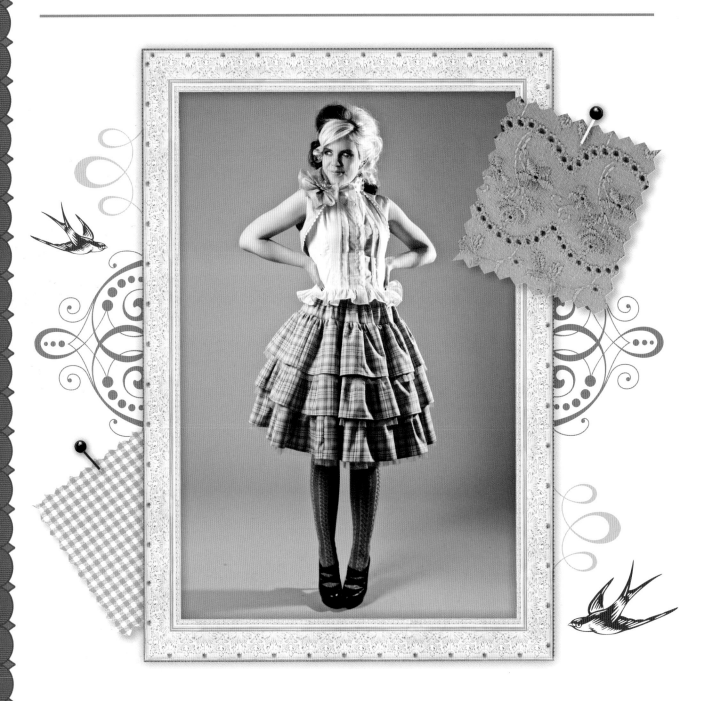

Start with a youthful, demure croquis.

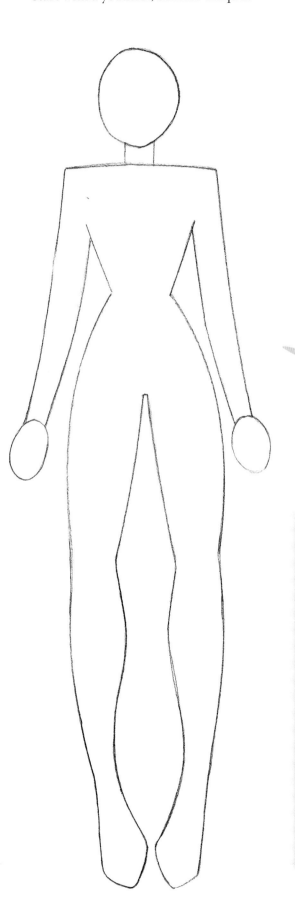

In recent years, Lolita has taken a rococo influence as well!

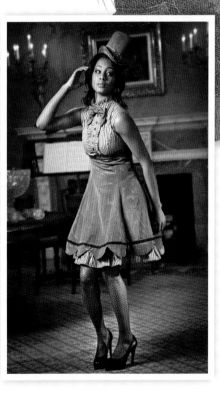

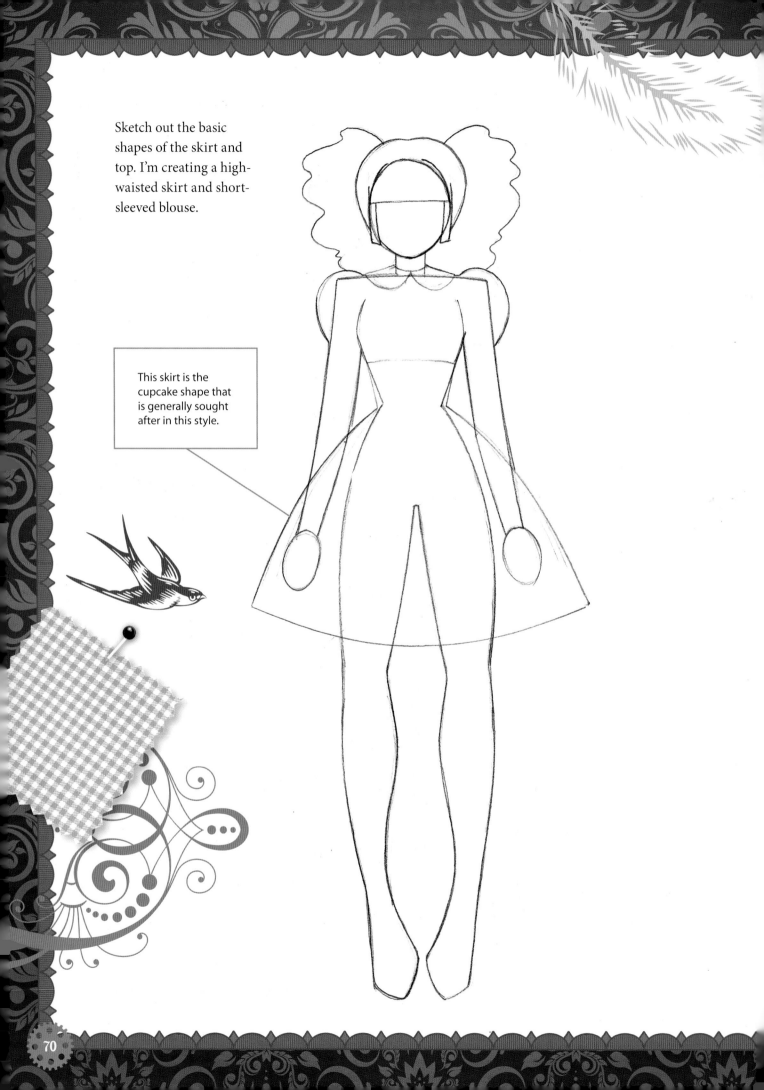

Sketch out the basic shapes of the skirt and top. I'm creating a high-waisted skirt and short-sleeved blouse.

This skirt is the cupcake shape that is generally sought after in this style.

BLOUSE VARIATIONS

If a blouse is worn in a Lolita look, it is always buttoned all the way up. These variations all have a Peter Pan collar, which is very popular in the Lolita style. For other collar design options, see page 38.

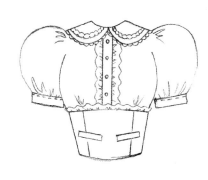

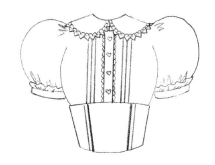

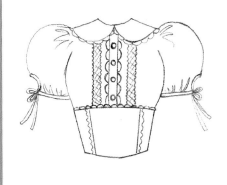

There are several skirt shapes worn in Lolita, most of which require a petticoat. Some styles are worn with a drop waist, but most are worn at the natural waist.

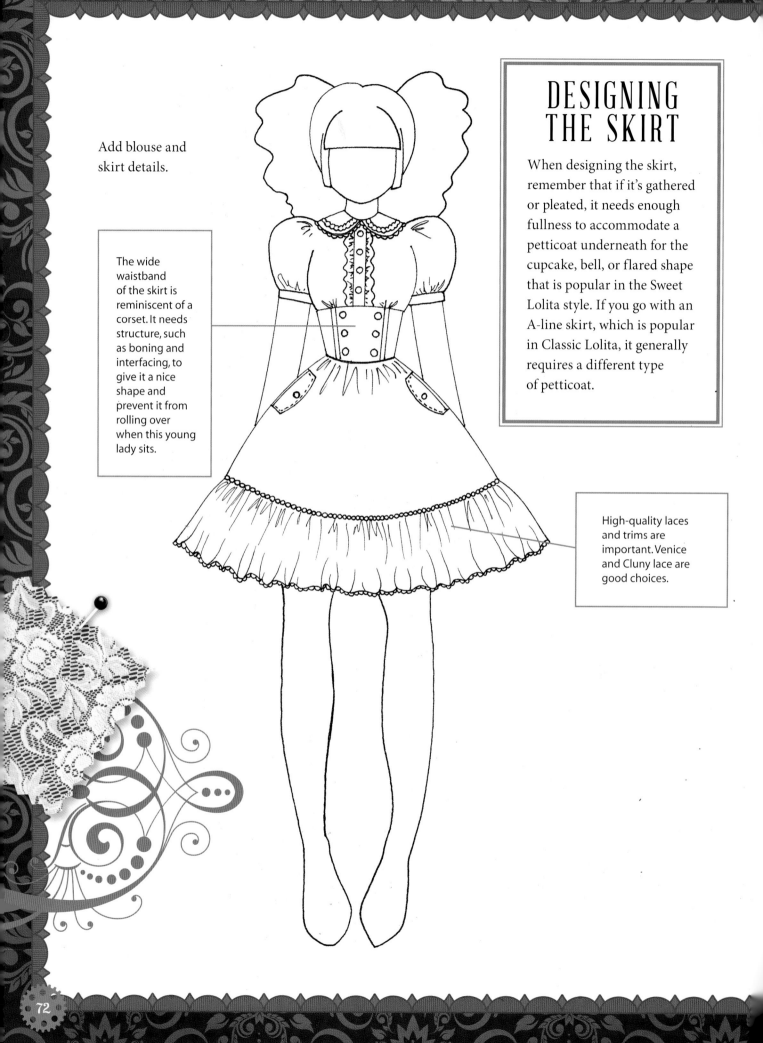

Add blouse and skirt details.

The wide waistband of the skirt is reminiscent of a corset. It needs structure, such as boning and interfacing, to give it a nice shape and prevent it from rolling over when this young lady sits.

DESIGNING THE SKIRT

When designing the skirt, remember that if it's gathered or pleated, it needs enough fullness to accommodate a petticoat underneath for the cupcake, bell, or flared shape that is popular in the Sweet Lolita style. If you go with an A-line skirt, which is popular in Classic Lolita, it generally requires a different type of petticoat.

High-quality laces and trims are important. Venice and Cluny lace are good choices.

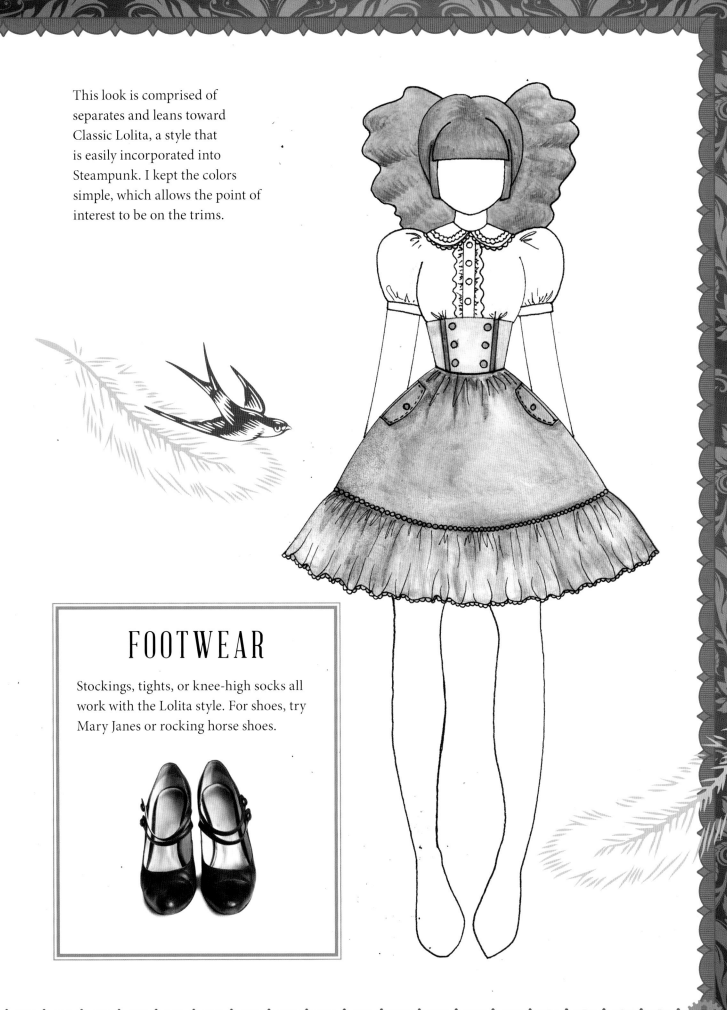

This look is comprised of separates and leans toward Classic Lolita, a style that is easily incorporated into Steampunk. I kept the colors simple, which allows the point of interest to be on the trims.

FOOTWEAR

Stockings, tights, or knee-high socks all work with the Lolita style. For shoes, try Mary Janes or rocking horse shoes.

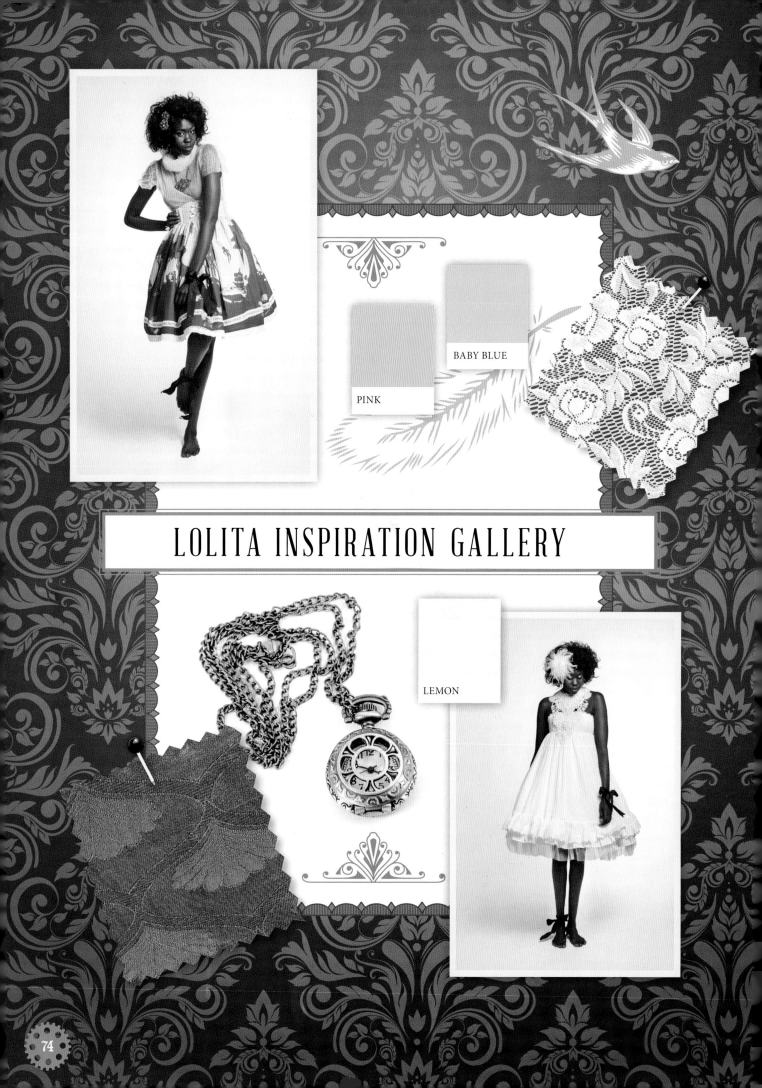

LOLITA INSPIRATION GALLERY

PINK

BABY BLUE

LEMON

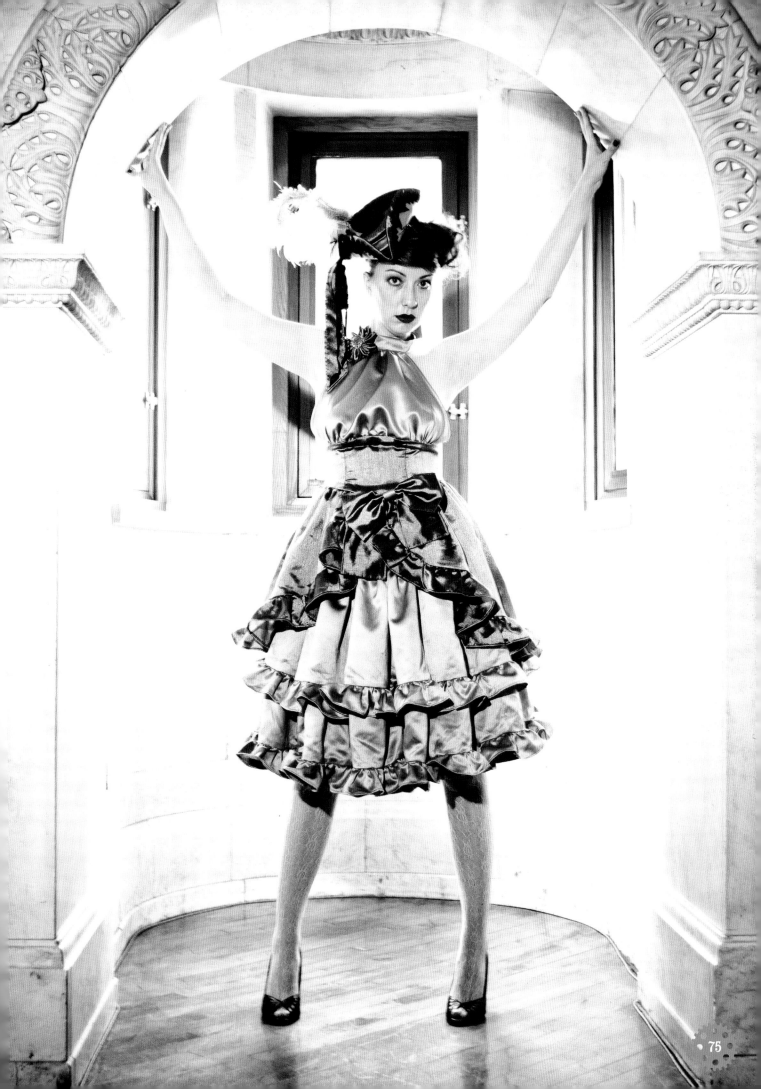

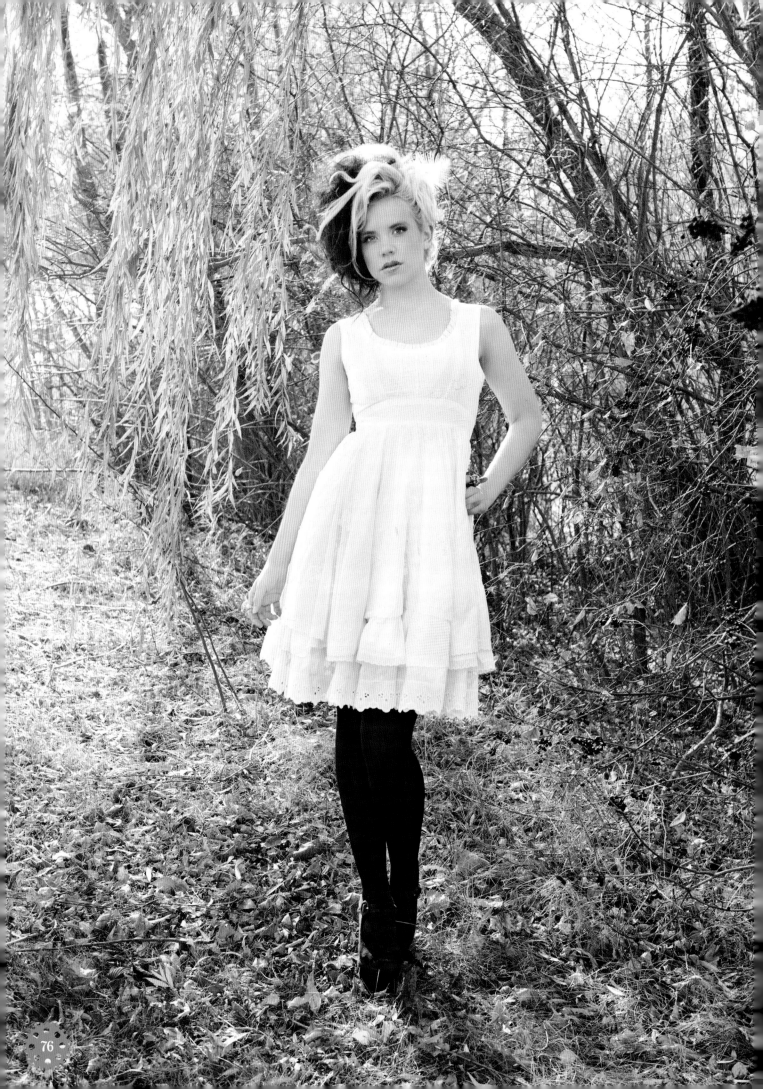

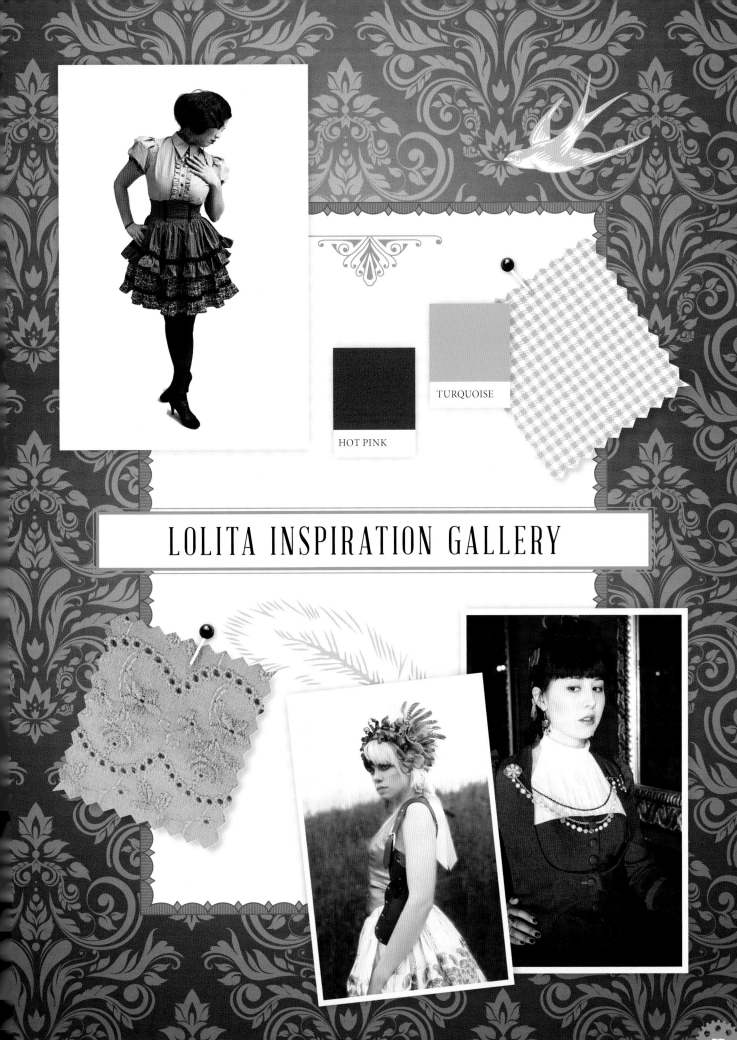

HOT PINK

TURQUOISE

LOLITA INSPIRATION GALLERY

STEAMGOTH

THERE IS A RUNNING JOKE that Steampunk is what happens when Goths discover brown. I like to say that this is both funny and inaccurate! Many people do think you need to wear brown to "be" Steampunk; however, this is incorrect—Victorians loved color, so there is no limit to the color you can use! So what happens when Goths discover Steampunk? Well, pretty much anything you can think of!

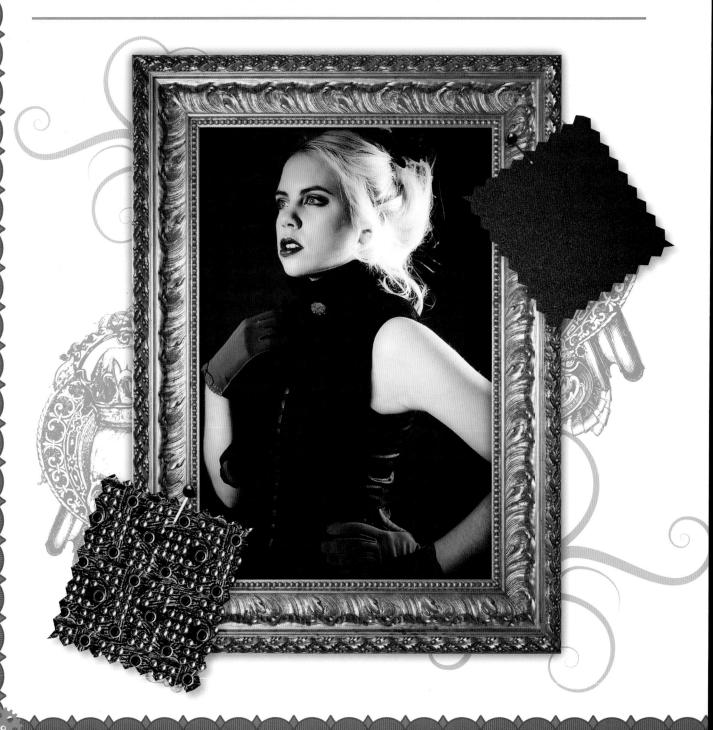

I'm going with an aristocratic look for my Steamgoth outfit. Everything will be quite fitted, so I start with a croquis that is set up for a mermaid skirt.

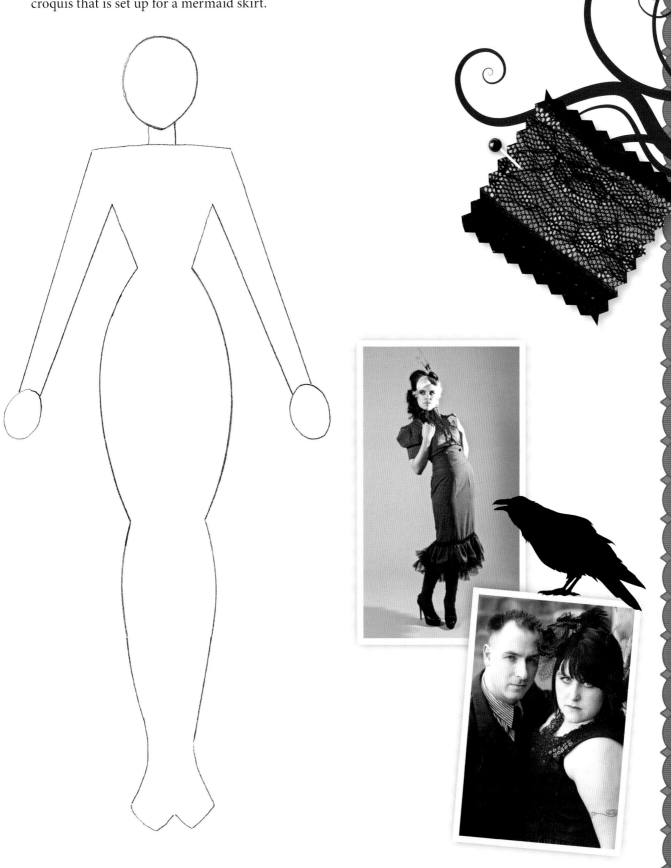

Sketch the outline of the skirt and blouse. I've added subdued leg-o-mutton sleeves to this outfit.

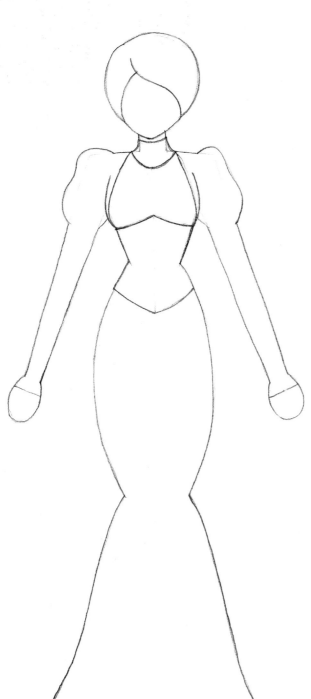

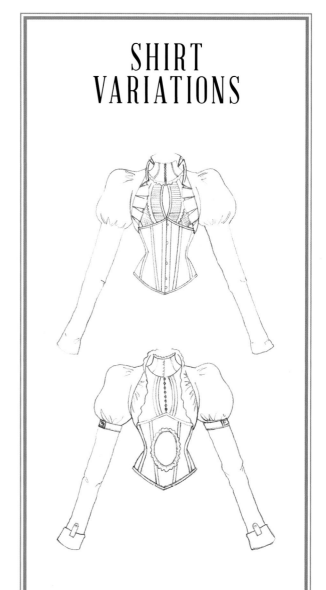

Since this will be a fairly monochromatic look, use of detail will create visual interest. For a more detailed look such as this, I work in stages to develop the areas of interest.

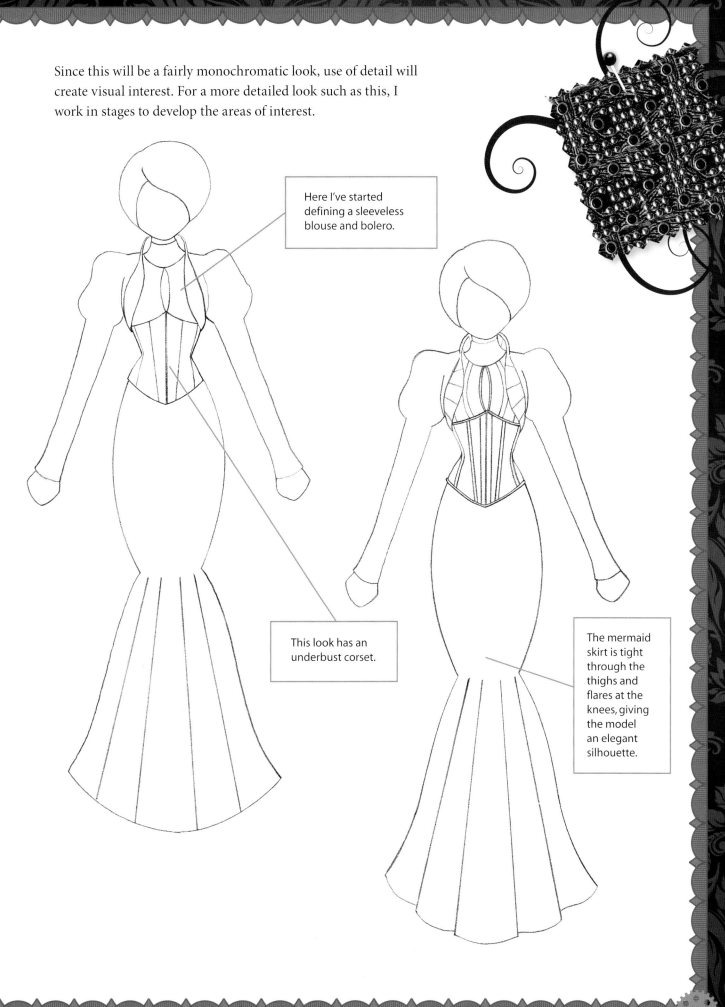

Here I've started defining a sleeveless blouse and bolero.

This look has an underbust corset.

The mermaid skirt is tight through the thighs and flares at the knees, giving the model an elegant silhouette.

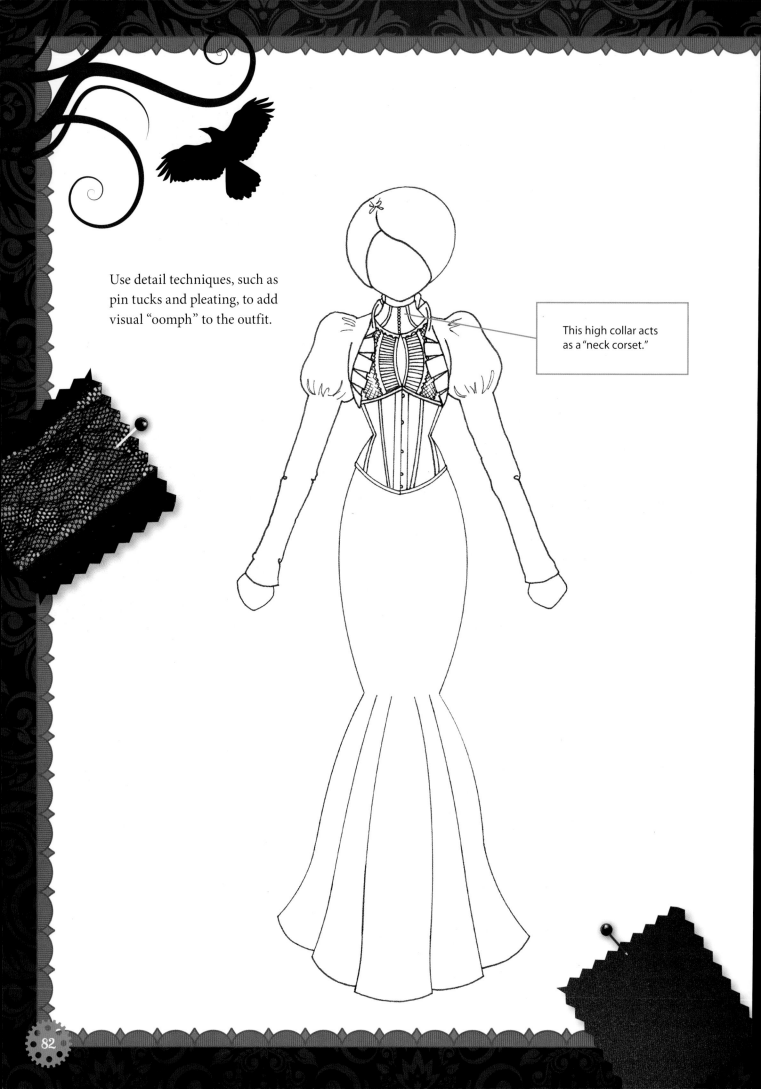

Use detail techniques, such as pin tucks and pleating, to add visual "oomph" to the outfit.

This high collar acts as a "neck corset."

When selecting fabrics and colors, it's a good rule of thumb to keep the Goth look dark. Black, gray, and jewel tones are great choices. For fabrics, you can use anything from solid silk and brocade to lightweight wool, leather, and latex.

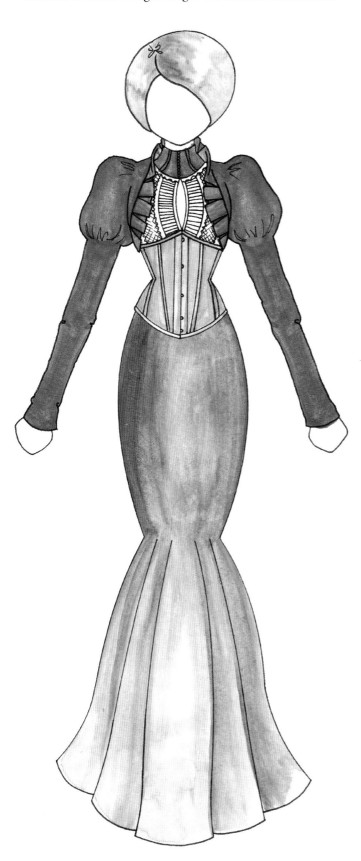

FASHION IN MOTION

Shake up your croquis by putting them in motion! A straight-on view is good for focusing on individual pieces of the outfit, but you can also highlight certain features of the design by using different angles.

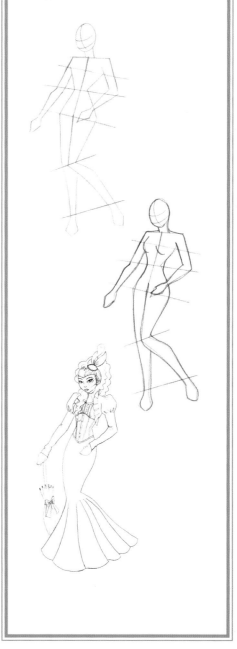

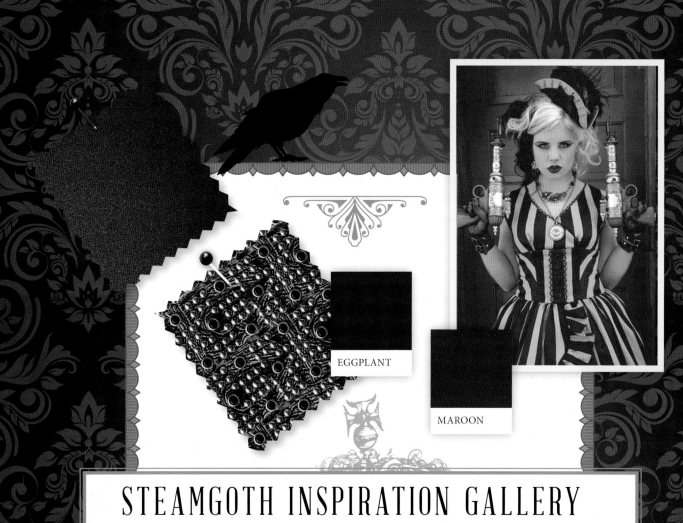

EGGPLANT

MAROON

STEAMGOTH INSPIRATION GALLERY

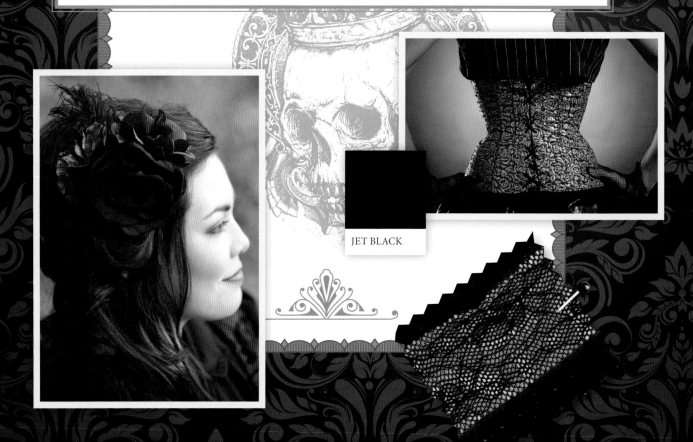

JET BLACK

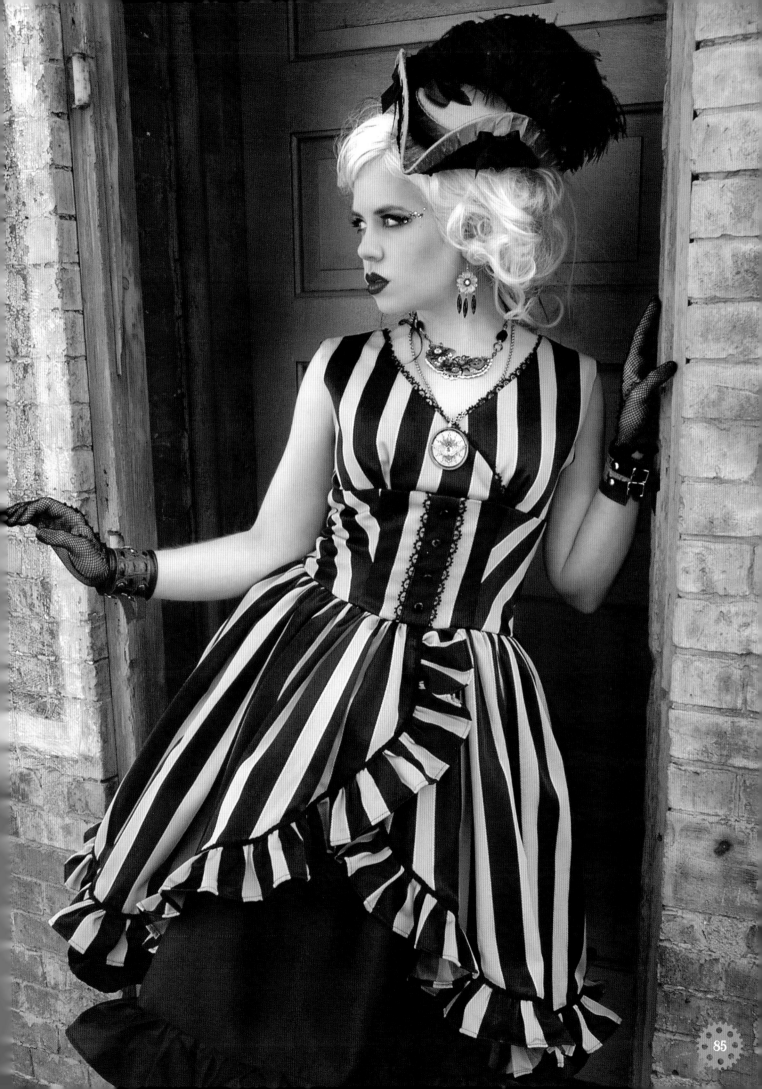

SKY PIRATE

ECLECTIC AND OFTEN MISMATCHED, the Sky Pirate wears an array of items collected during her travels, lacking the polished and refined look other Steampunk archetypes. The Sky Pirate carries a variety of practical gadgets, such as goggles, a telescope, and a compass, as well as weapons for hand-to-hand combat.

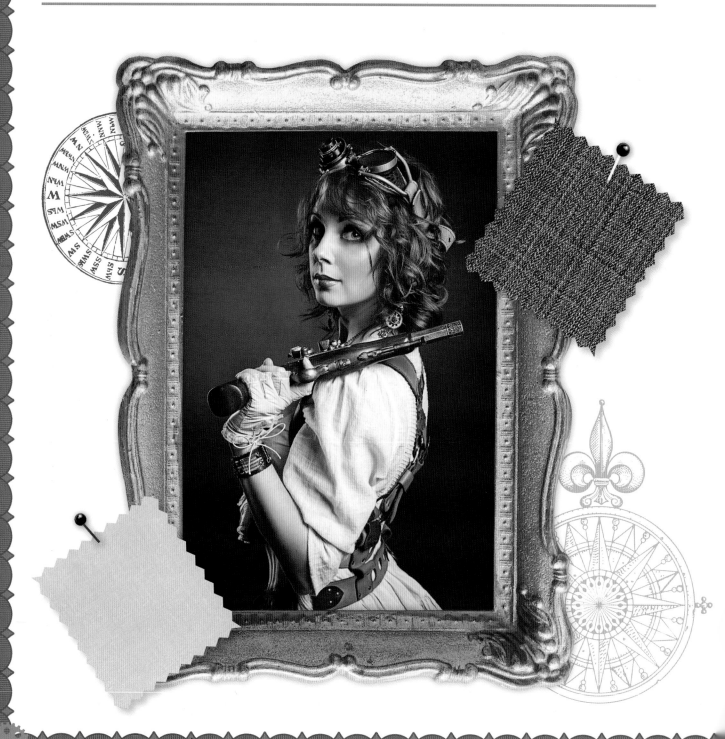

Start with an outline. Remembering that this look is all about adventure, I sketch some breeches on my croquis to allow for agility and maximum range of motion.

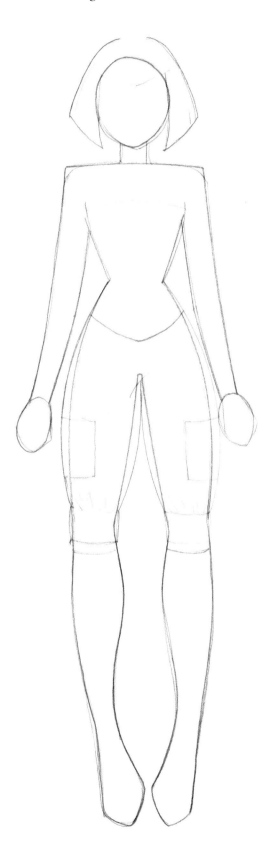

CORSET STYLES

A leather corset is a stable choice suitable for both fighting and working. Don't add too many layers to this look, since leather is a hefty fabric.

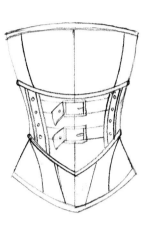

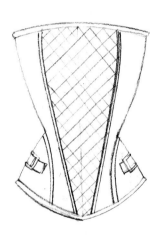

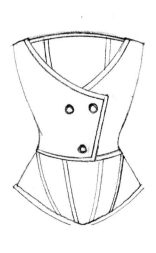

Decide what the pirate will wear under the corset. Design something with a little bulk. Anything from a camisole to a blouse can work for this look.

ACCESSORIES & EMBELLISHMENTS

Don't forget a hat! What is a pirate without an amazing headpiece? I'm also giving my pirate leather emergency escape wings.

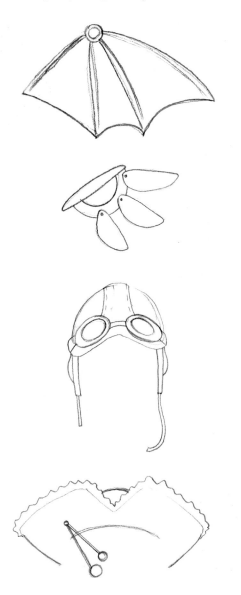

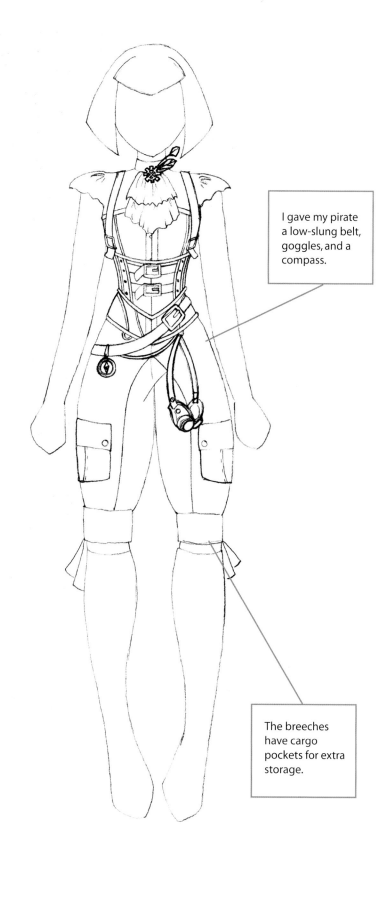

I gave my pirate a low-slung belt, goggles, and a compass.

The breeches have cargo pockets for extra storage.

Select your colors. I chose
subtle shades, with an accent
color. For this look I would
suggest utilitarian fabrics,
such as canvas or denim.

*Be sure to envision
all your garments as
they will look in your
fabric choices. You may
find that some designs
just don't work with
the fabric. Thinking
about it ahead of
time will allow you
to make changes in
your designs.*

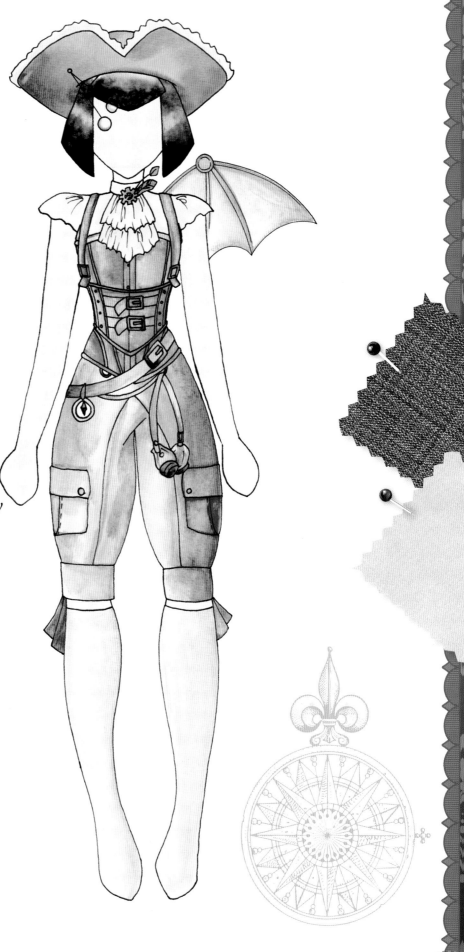

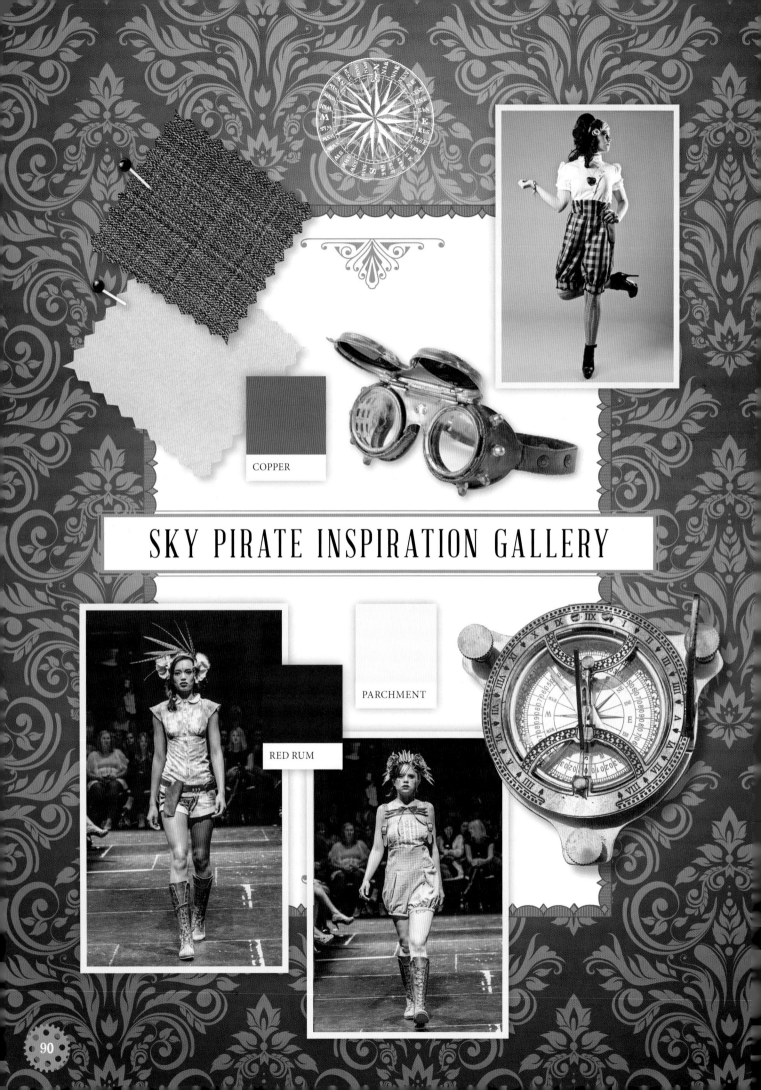

SKY PIRATE INSPIRATION GALLERY

COPPER

PARCHMENT

RED RUM

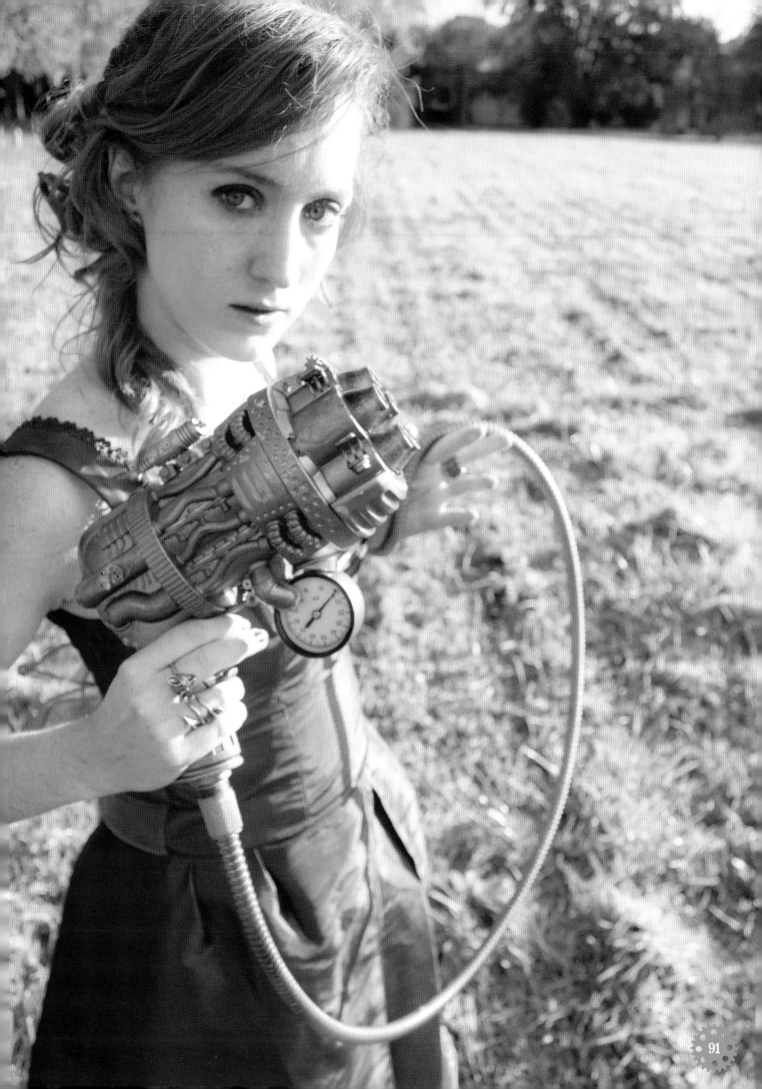

WEIRD WEST

THE GUN-SLINGING, Weird West character wears clothing practical for activities such as hunting and fighting: knee-high boots, skirts or trousers, and ruffled blouses reminiscent of the Victorian era for women; long jackets and wide-brimmed hats for men. Weaponry is a focal point of the outfit.

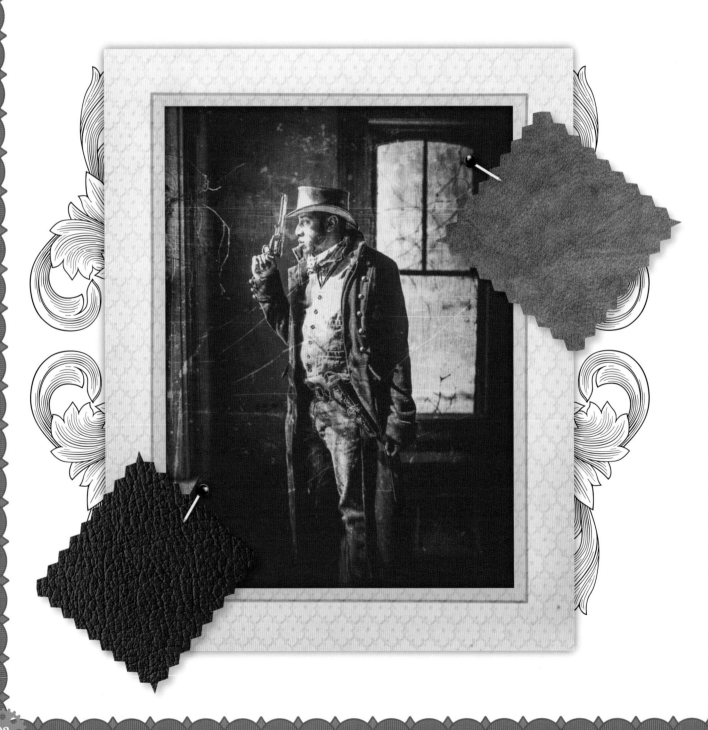

Start with a male croquis in a strong pose.

Begin outlining the basic outfit. I've drawn simple trousers, a vest, and a shirt.

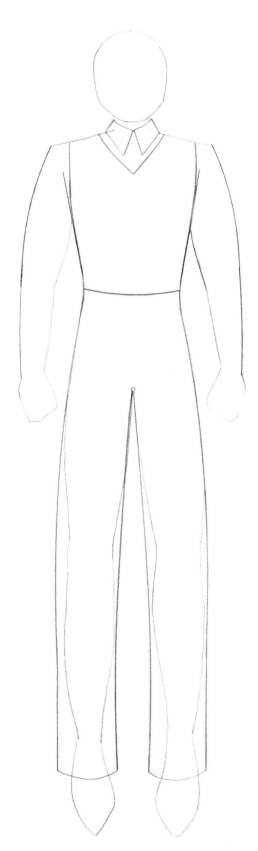

VEST VARIATIONS

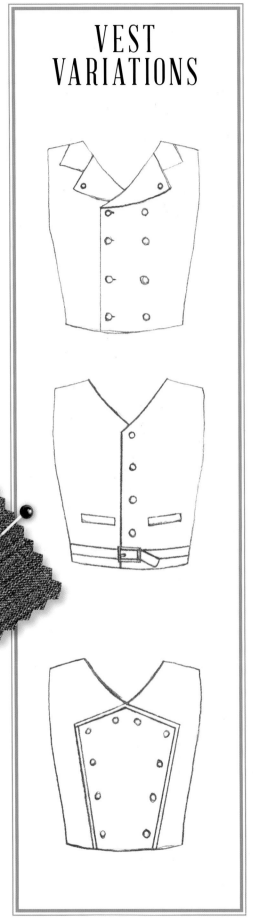

A long trench coat is an essential for this look. Try sketching it out separately before adding the coat to your croquis.

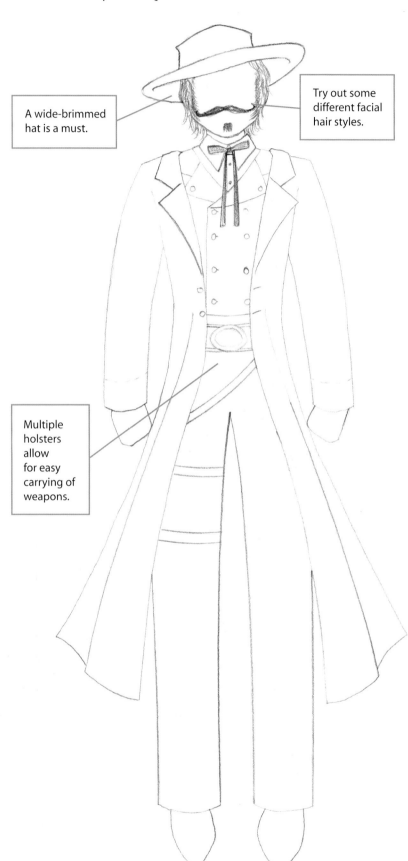

A wide-brimmed hat is a must.

Try out some different facial hair styles.

Multiple holsters allow for easy carrying of weapons.

MUSTACHE VARIATIONS

Finish by adding color. Fabrics in neutral colors, such as brown and black, are good choices for this look.

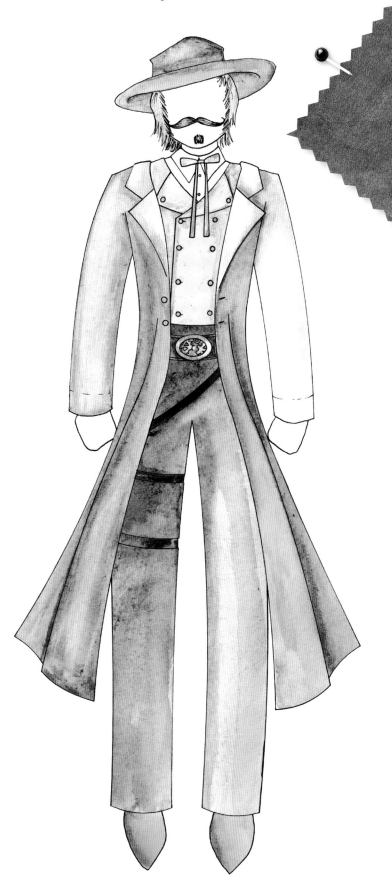

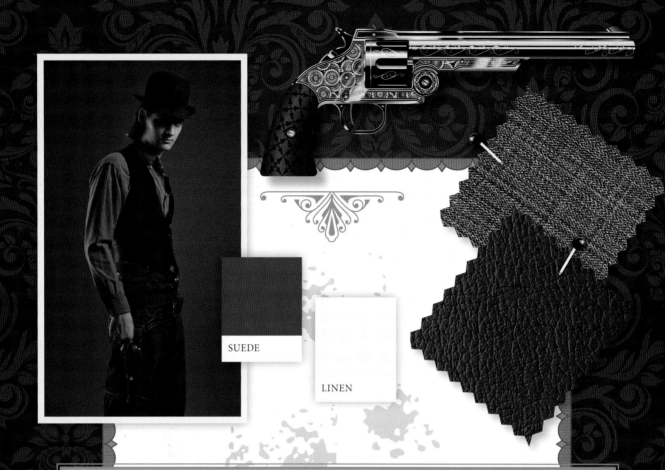

SUEDE

LINEN

WEIRD WEST INSPIRATION GALLERY

STEEL

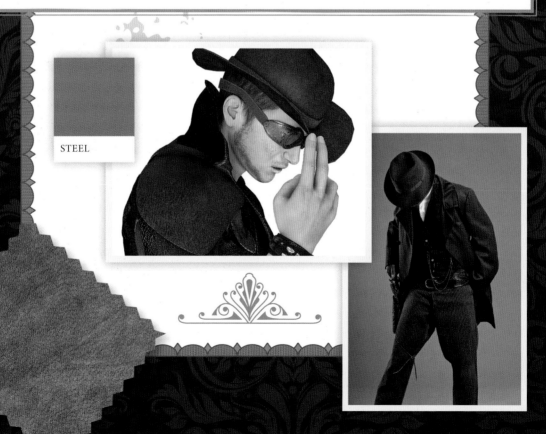

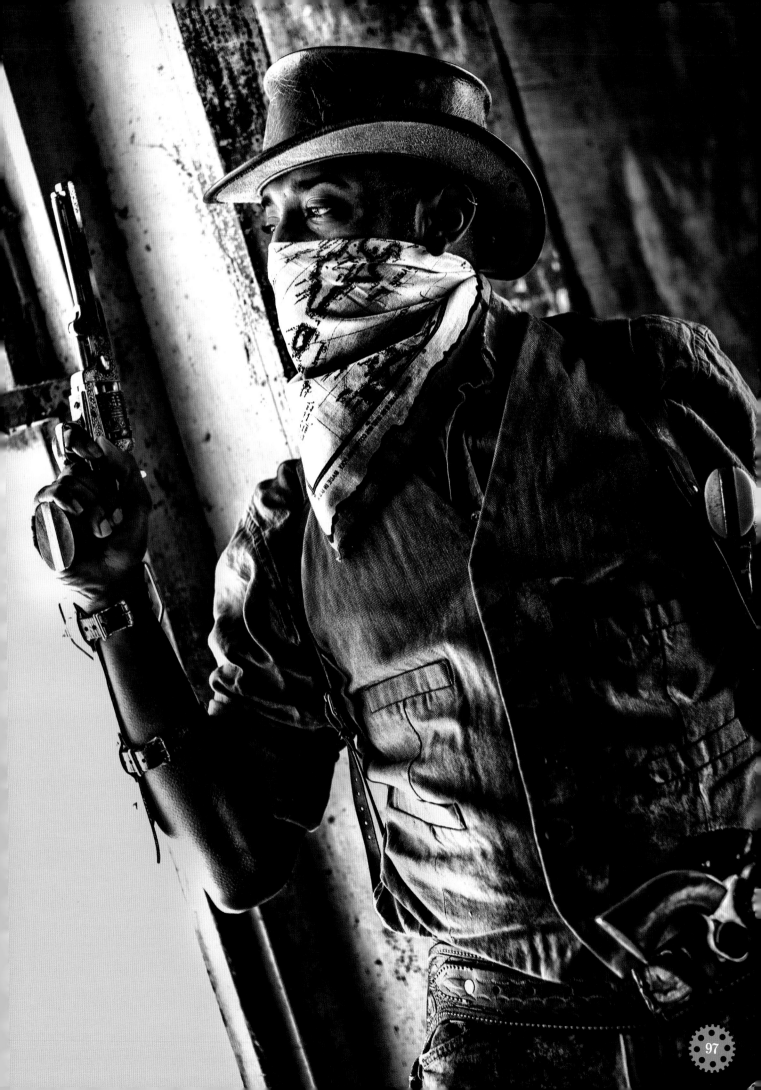

TRIBAL FUSION

A TRIBAL FUSION LOOK REQUIRES a lot of research if you are not already familiar with the subject matter. Belly dancing is an Eastern style of dance that has picked up a lot of steam in the Western Hemisphere, spawning this uniquely Western take called "Tribal Fusion." It incorporates things like hip-hop music and Gothic or Steampunk costuming elements with traditional techniques and costume.

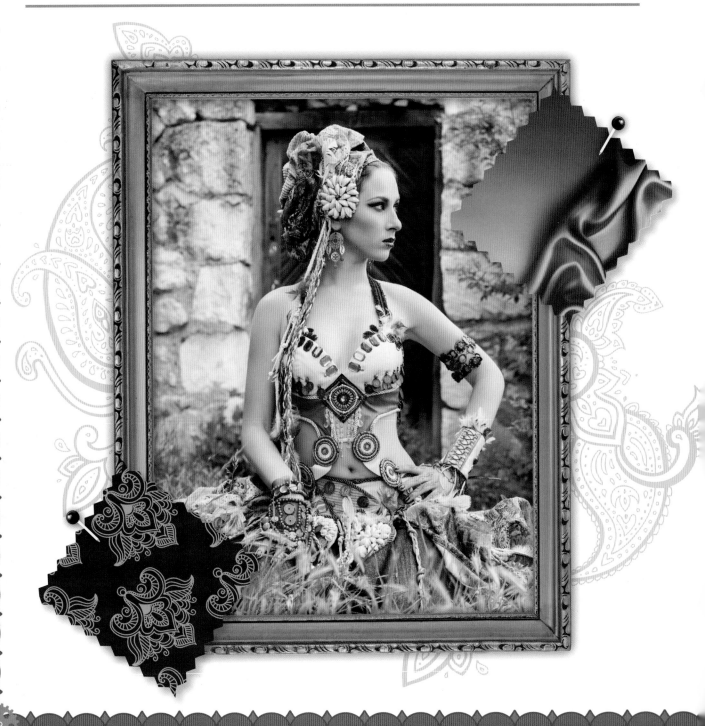

Begin with your croquis.
I've drawn mine head-on
so you can see the elements
of the costume, but it
would be fun to sketch
your outfit on a croquis in
a belly-dancing pose too!

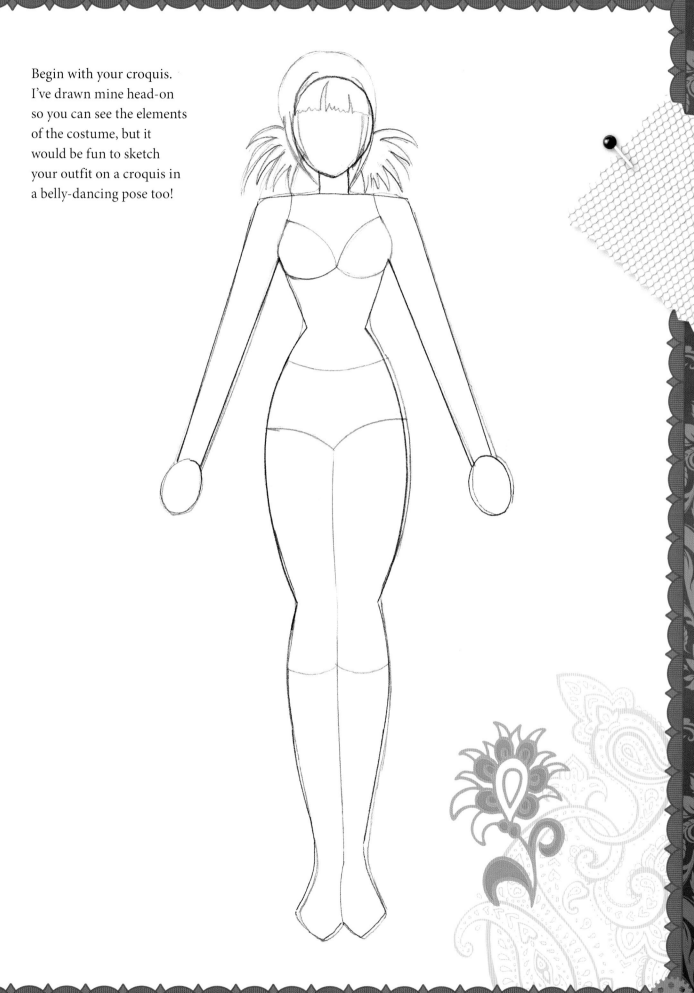

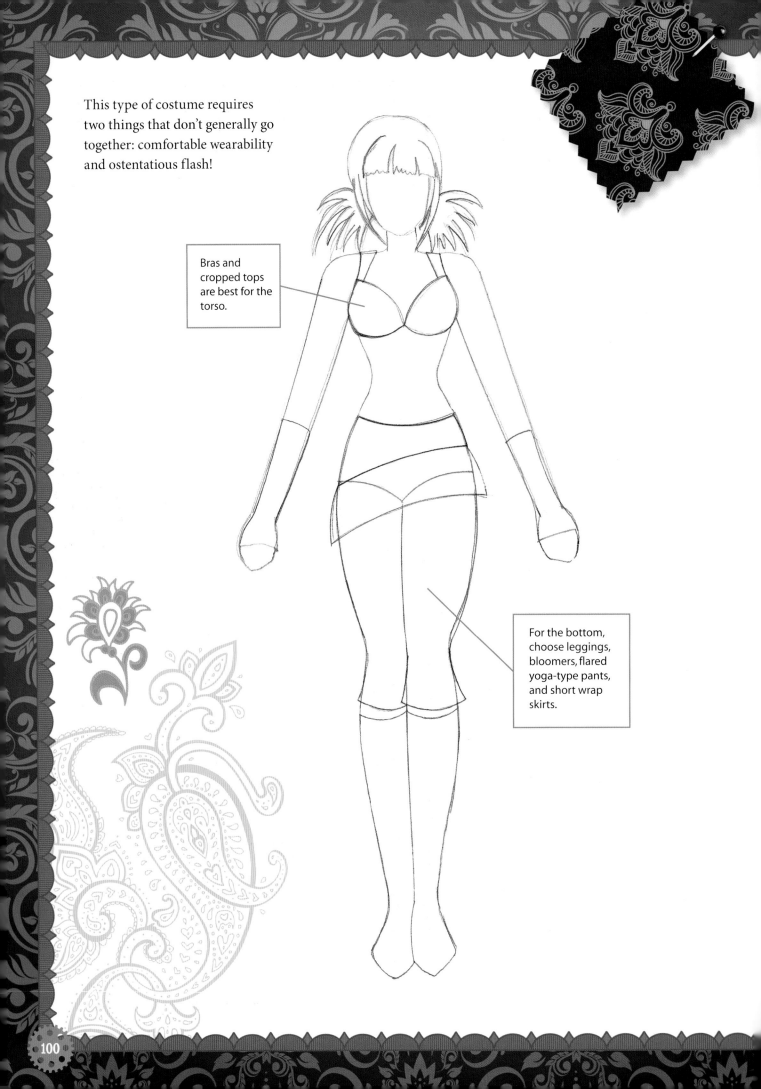

This type of costume requires two things that don't generally go together: comfortable wearability and ostentatious flash!

Bras and cropped tops are best for the torso.

For the bottom, choose leggings, bloomers, flared yoga-type pants, and short wrap skirts.

TOP
VARIATIONS

You can go all out when adding design
details, such as ruffles, lace, tassels,
fringe, and ribbon.

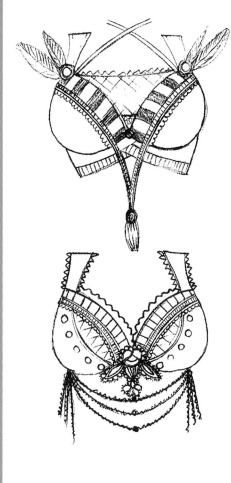

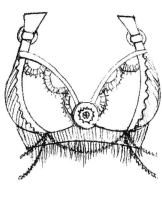

BLOOMER
VARIATIONS

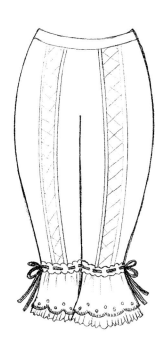

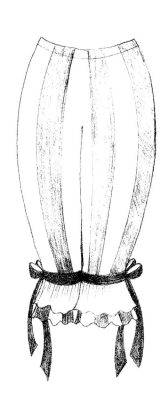

I designed an elaborate bra, pantaloons, miniskirt, and headdress. I also gave her flared leg warmers, lace-up arm warmers, and a bustle with netting.

MINISKIRT VARIATIONS

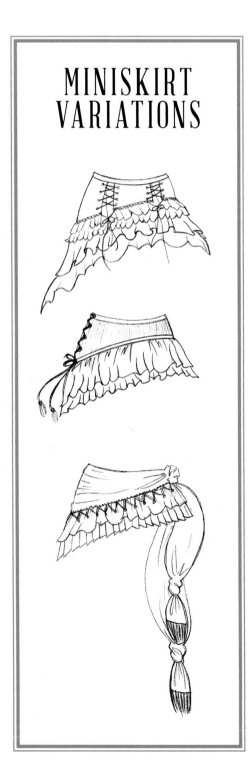

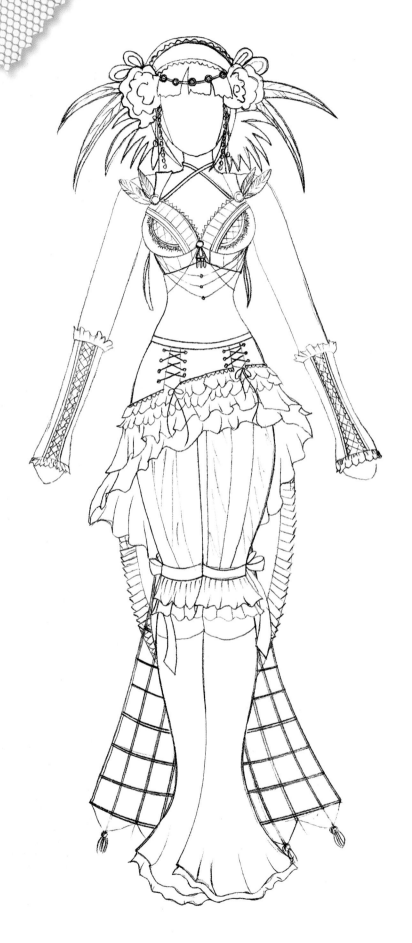

I add some sound elements, such as beads and coins, so when she moves, you can hear it! Choose fabrics with good stretch for costumes like this, as they give the dancer better range of motion.

Many dancers wear bustles, elaborate headpieces, jewelry, and armbands.

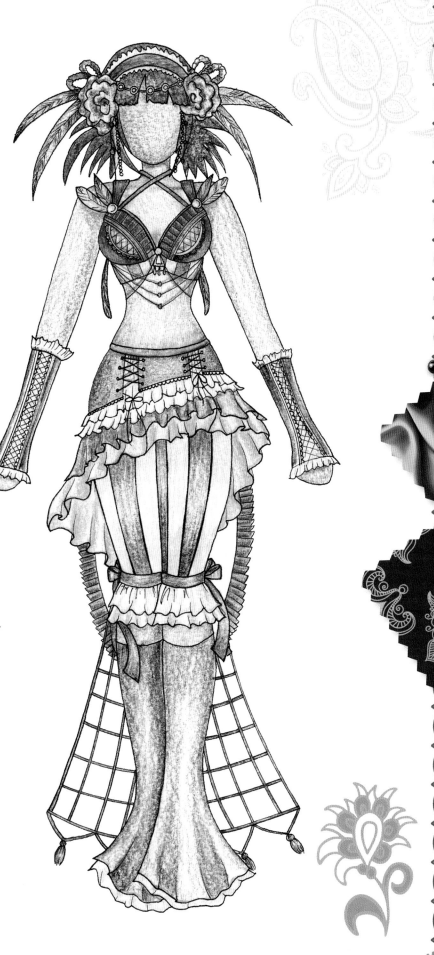

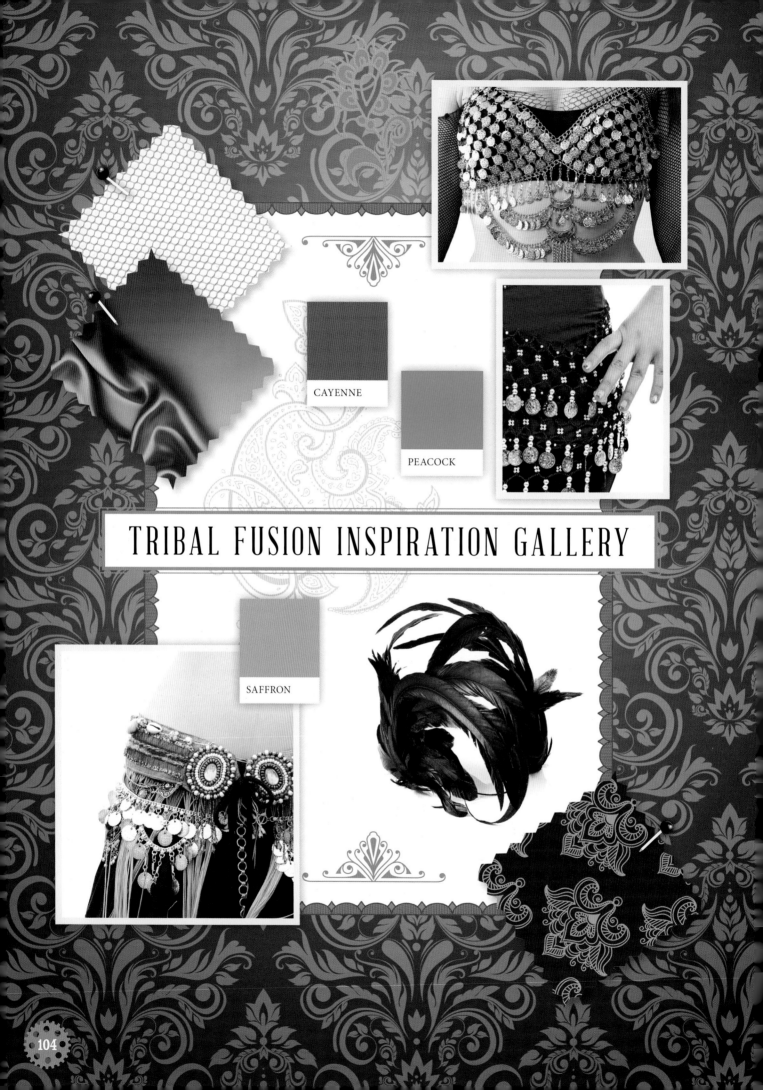

TRIBAL FUSION INSPIRATION GALLERY

CAYENNE

PEACOCK

SAFFRON

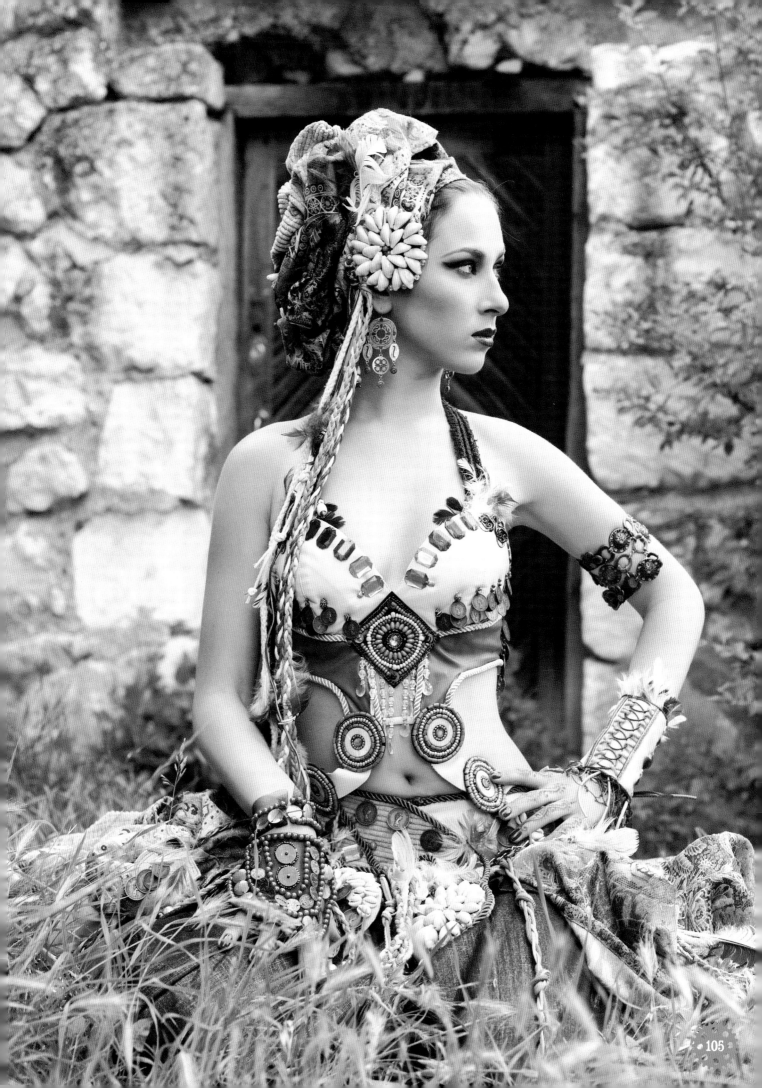

CLOCKPUNK

CLOCKPUNK IS AN INTERESTING subgenre of Steampunk. When the word was first used, it was considered to be Galileo's time (1564–1642) with "modern" tech powered by clocks instead of steam. Currently, more people consider Clockpunk to be an ensemble with a variety of clock elements.

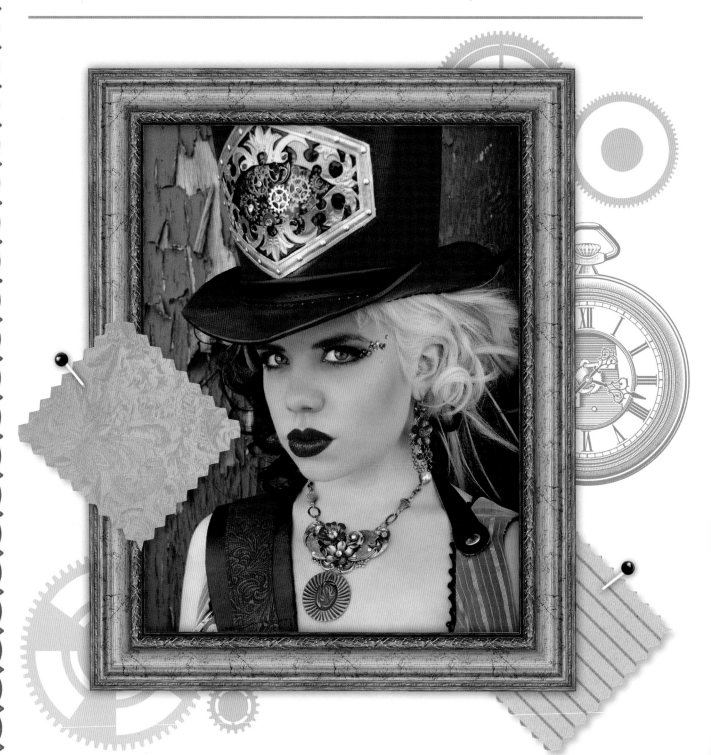

Begin with an initial croquis, and outline the outfit. I'm creating a full knee-length skirt, a high-collared sleeveless blouse, and a corset.

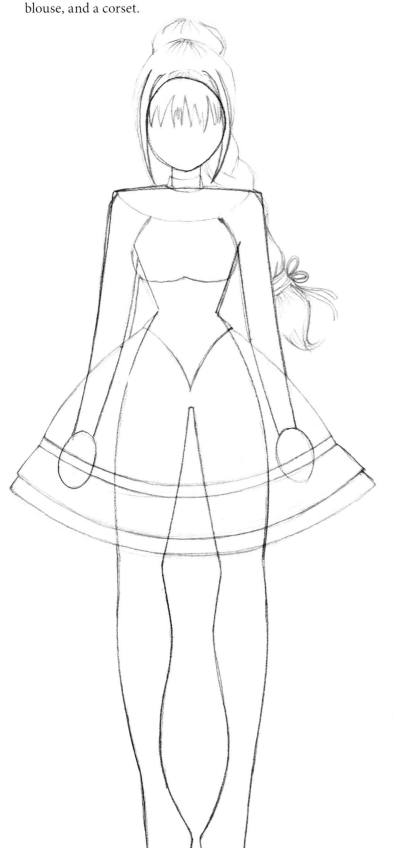

It's important to stay true to yourself as a designer, but it is equally important to do your research and pay attention to trends. If a look is not culturally relevant, it may not sell.

Add details to the outfit.

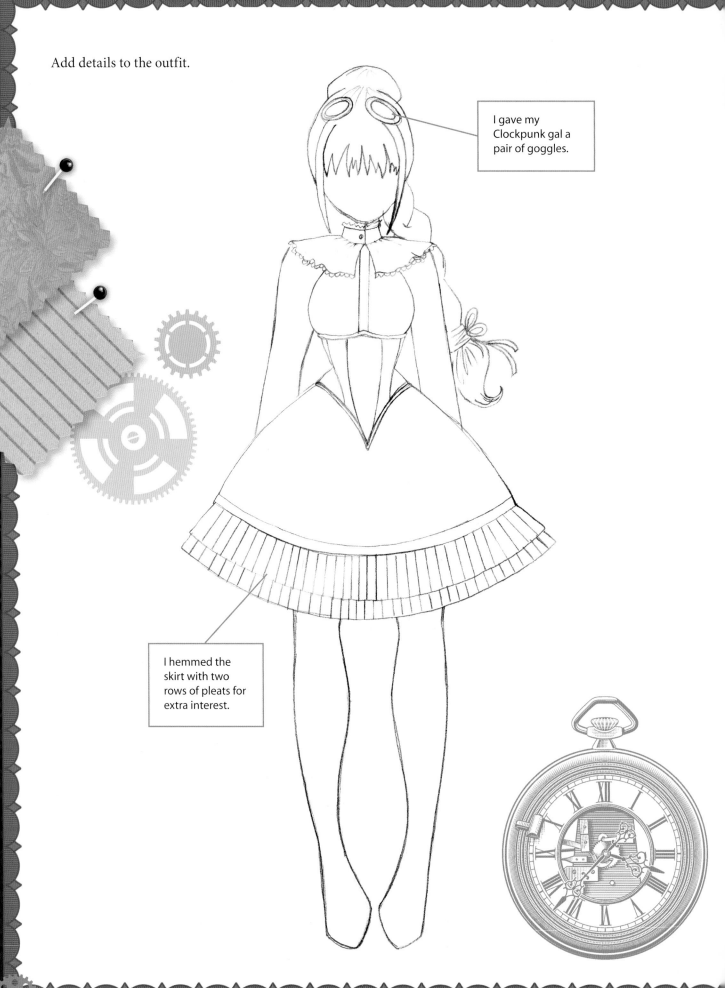

I gave my Clockpunk gal a pair of goggles.

I hemmed the skirt with two rows of pleats for extra interest.

I played around with different ways of incorporating clock gears into the corset. Any of these variations instantly adds a Clockpunk element to the outfit.

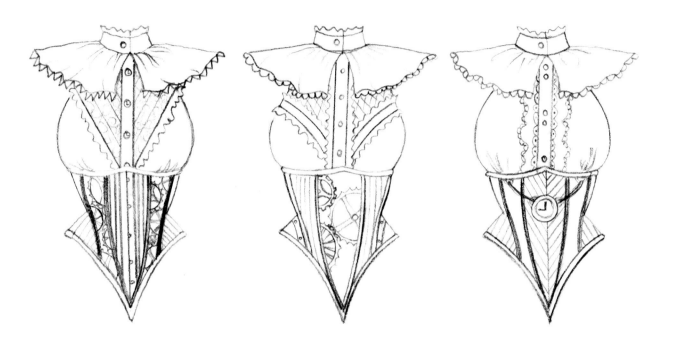

SPECIAL DETAILS

I wanted to add Clockpunk wings, inspired in part by Leonardo da Vinci and in part by the manga series *Clover*.

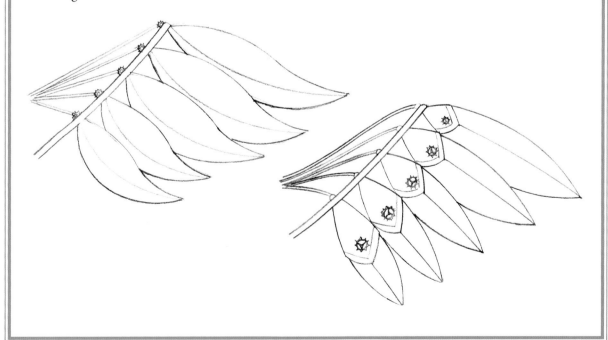

Add final details.

The blouse
has intricate
feminine details.

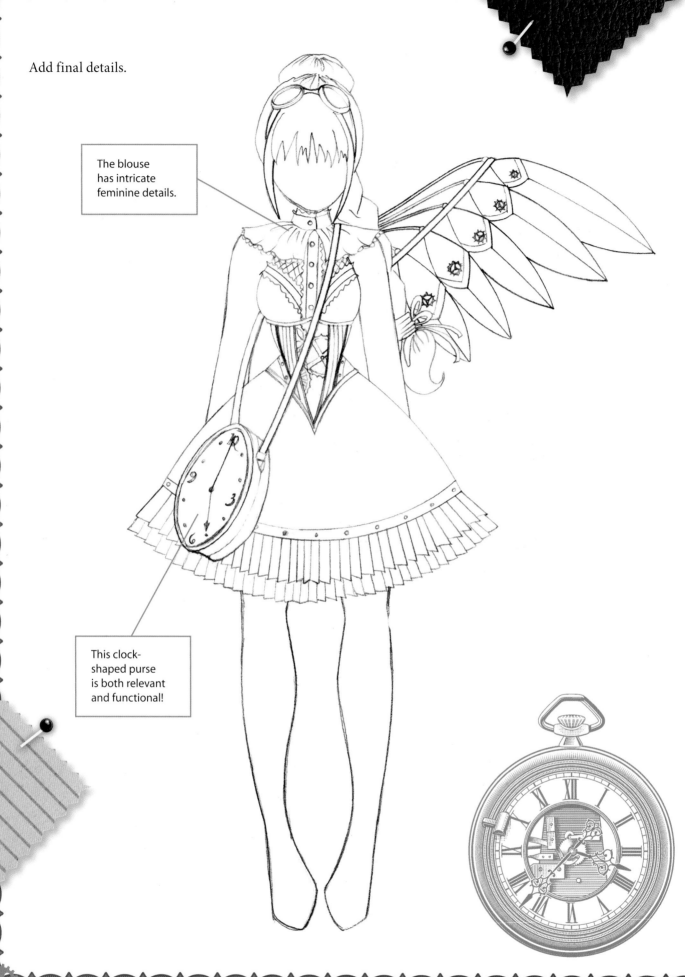

This clock-
shaped purse
is both relevant
and functional!

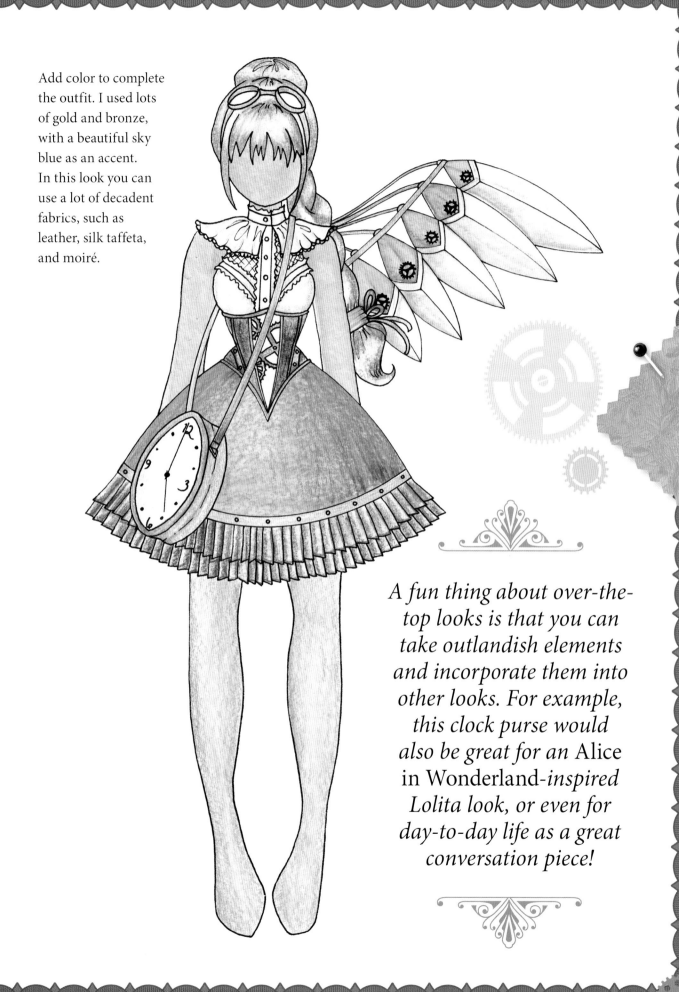

Add color to complete the outfit. I used lots of gold and bronze, with a beautiful sky blue as an accent. In this look you can use a lot of decadent fabrics, such as leather, silk taffeta, and moiré.

A fun thing about over-the-top looks is that you can take outlandish elements and incorporate them into other looks. For example, this clock purse would also be great for an Alice in Wonderland-*inspired* Lolita look, or even for day-to-day life as a great conversation piece!

GOLD

METAL

CLOCKPUNK INSPIRATION GALLERY

CRIMSON

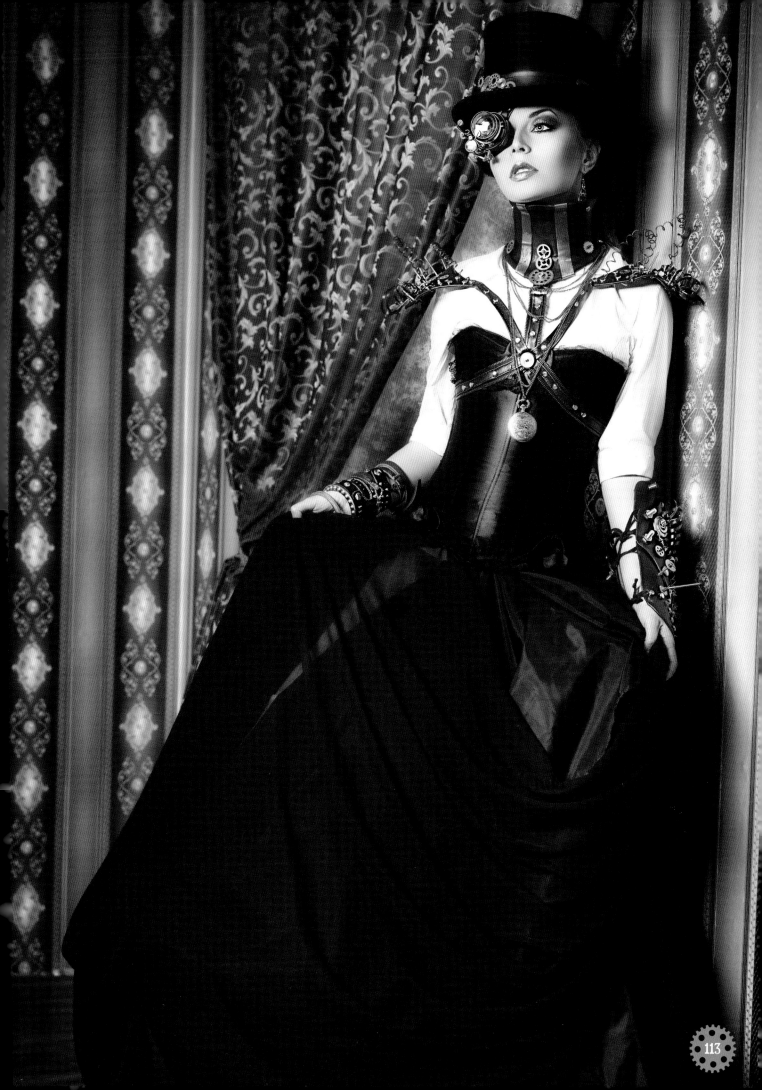

EXPLORER

SUITED FOR ADVENTURE, the Explorer wears clothing reminiscent of formalwear but more utilitarian: short skirts (with or without a bustle), corsets, and sturdy footwear. Khaki and leather are common fabrics suitable for exploring uncharted territories. The Explorer may wear body armor and weapons, navigation and communication devices, and pouches for holding unearthed treasures.

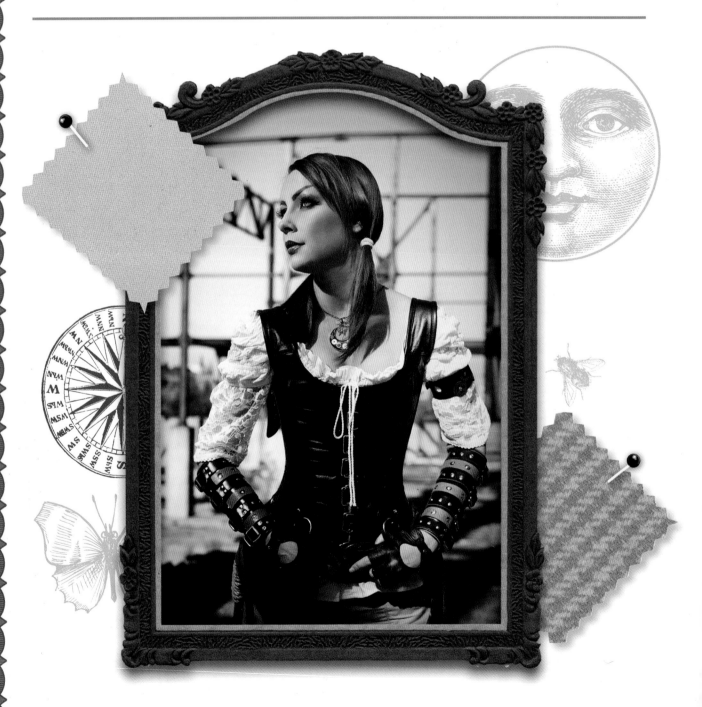

Start with your croquis and a basic outline of the outfit. I'm giving this female explorer an overbust corset, a short-sleeved blouse, and a knee-length convertible skirt.

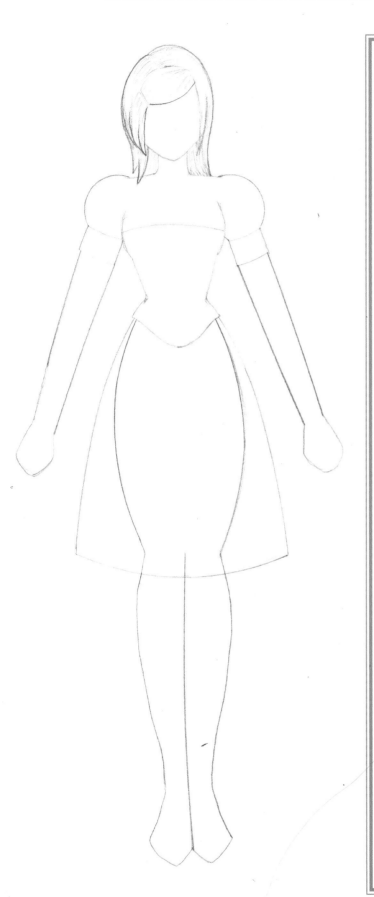

BLOUSE & CORSET VARIATIONS

The corset I've designed is made out of leather, which is sturdy and can stand up to the elements. The blouse is slightly low-cut to allow for good air circulation in warm environments.

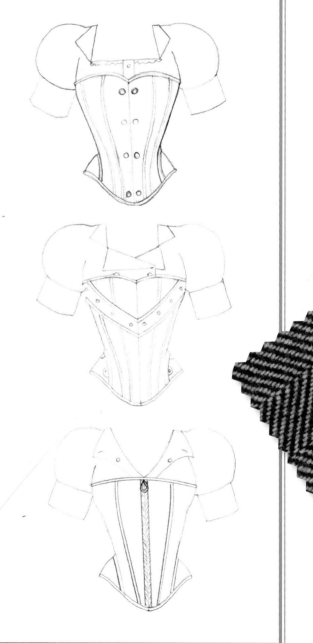

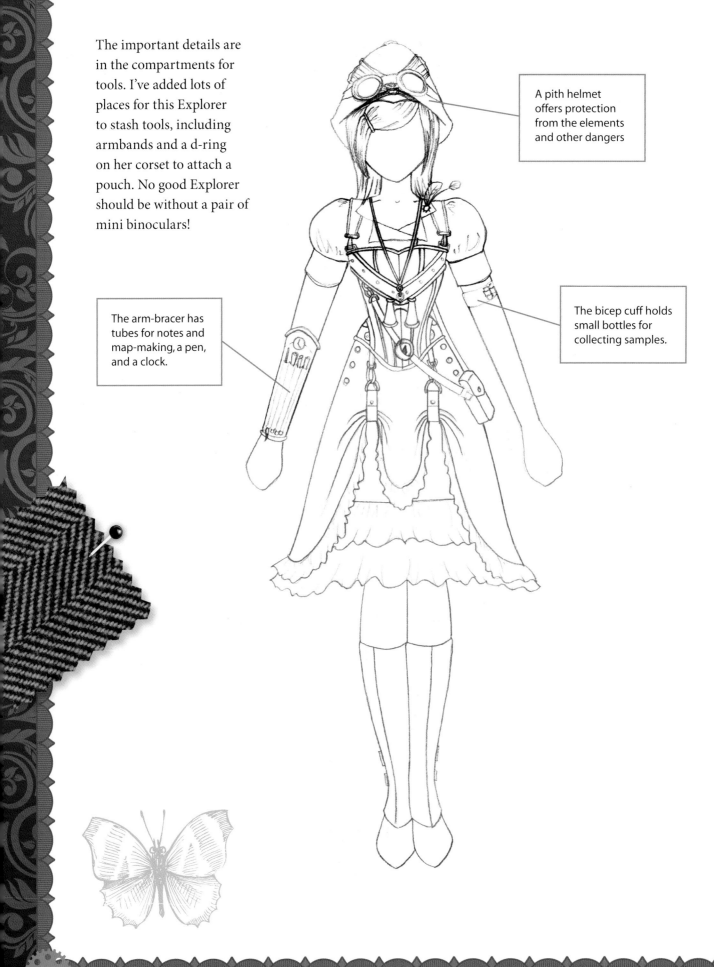

The important details are in the compartments for tools. I've added lots of places for this Explorer to stash tools, including armbands and a d-ring on her corset to attach a pouch. No good Explorer should be without a pair of mini binoculars!

A pith helmet offers protection from the elements and other dangers

The arm-bracer has tubes for notes and map-making, a pen, and a clock.

The bicep cuff holds small bottles for collecting samples.

Time to add color. I chose sandy, neutral colors, except for the convertible overskirt, which is rusty red. This detachable item can double as an emergency flag in vast brown and green landscapes. It can also be easily removed with side buttons if she needs to hide. Now that's an outfit that is both functional and looks good!

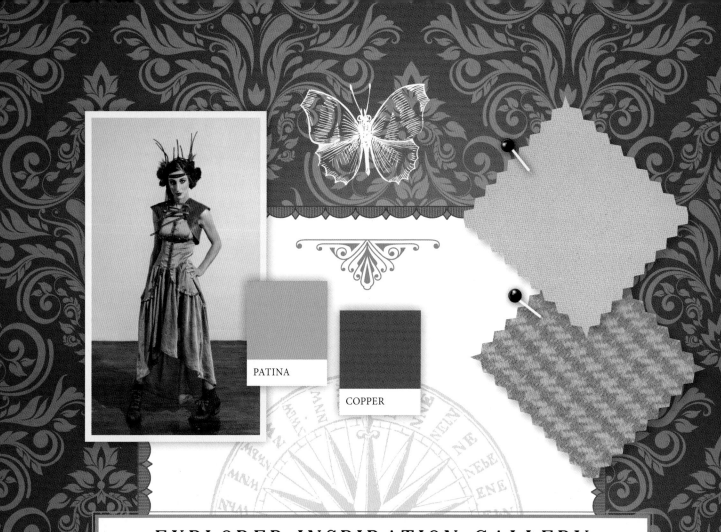

PATINA

COPPER

EXPLORER INSPIRATION GALLERY

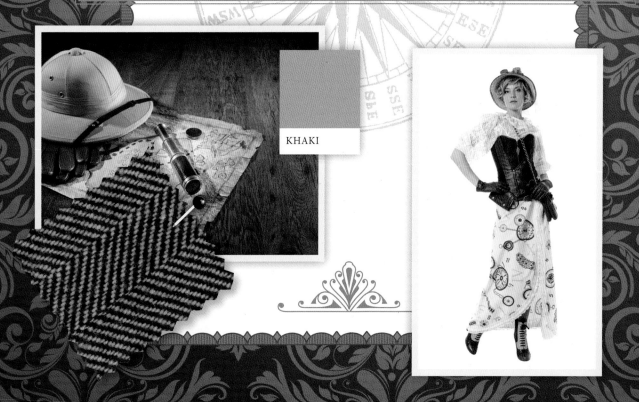

KHAKI

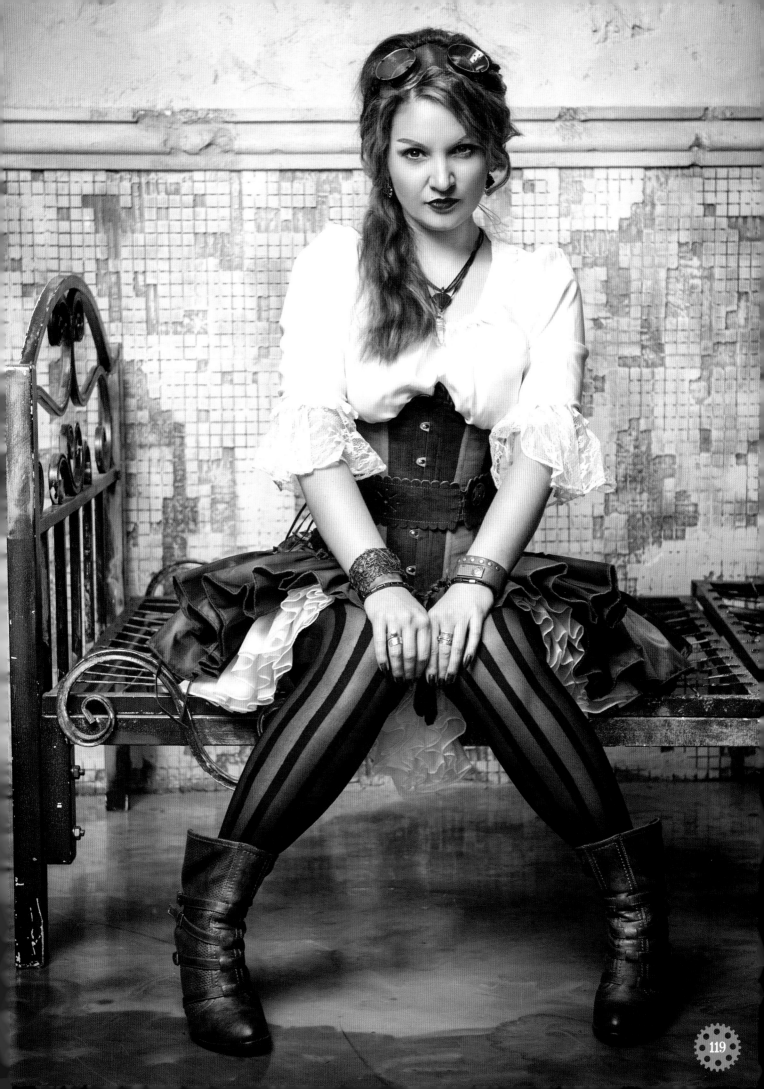

ROCOCOPUNK

A BLEND OF ORNATE ROCOCO and colorful punk styles, the Rococopunk look is full of decadent color palettes, dramatic hair and makeup, and corsets and pirate jackets. This punk take on the high-class artistic movement of the late Baroque period is fun, edgy, and sexy.

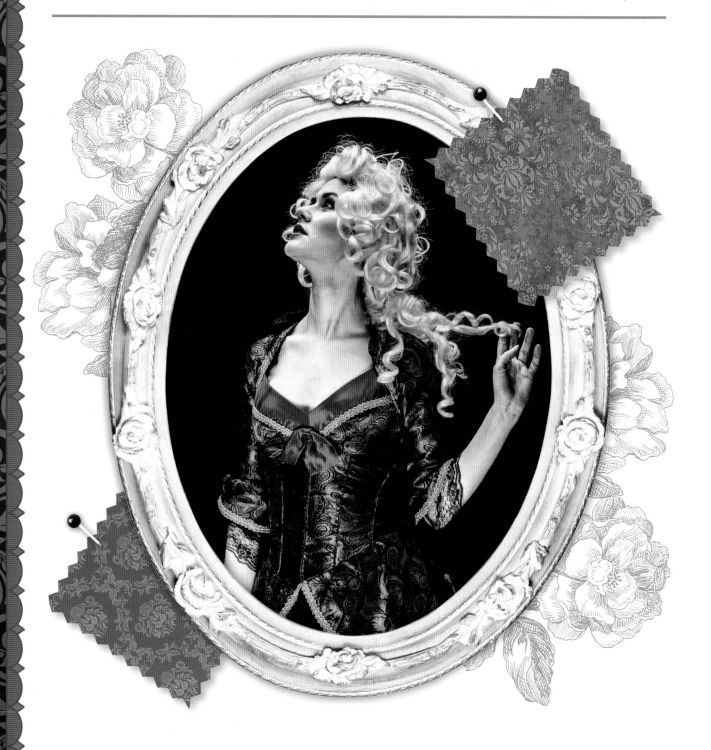

Sketch your costume idea onto a basic frame.

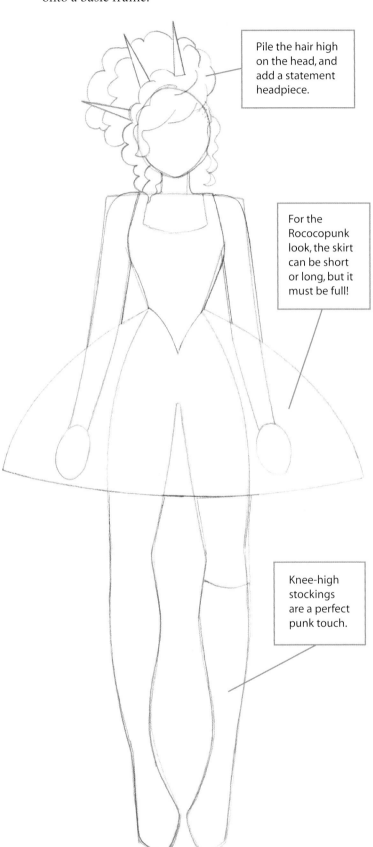

Pile the hair high on the head, and add a statement headpiece.

For the Rococopunk look, the skirt can be short or long, but it must be full!

Knee-high stockings are a perfect punk touch.

CORSET STYLES

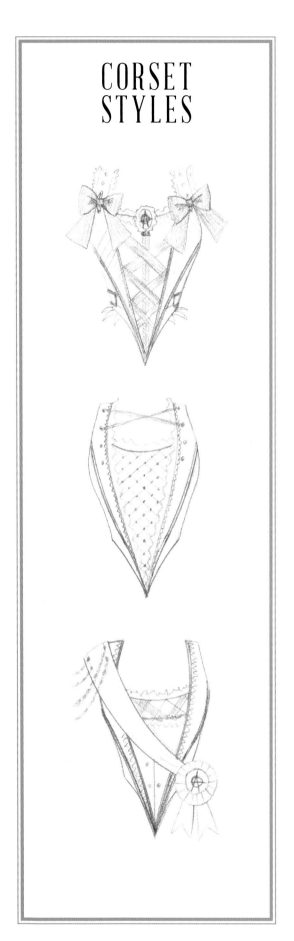

Add details to the outfit. Be elaborate!

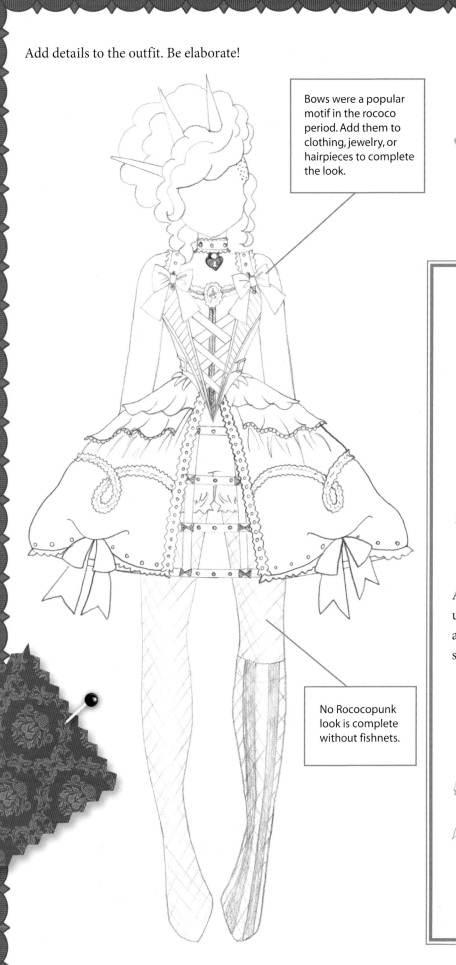

Bows were a popular motif in the rococo period. Add them to clothing, jewelry, or hairpieces to complete the look.

No Rococopunk look is complete without fishnets.

SKIRT STYLES

Panniers, or wide hoops, worn under the skirt were a staple of rococo fashion for women.

A full skirt without panniers was usually cut longer in the back to form a small train. Try adding a train to a short skirt for a Rococopunk look.

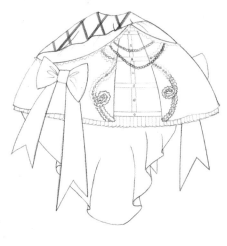

Finish the look with color, using the medium of your choice. The Rococopunk look is full of rich colors, so don't be afraid to go wild.

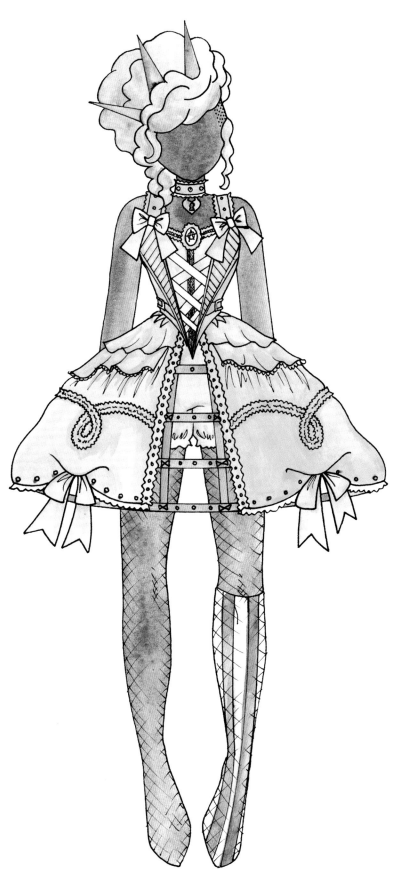

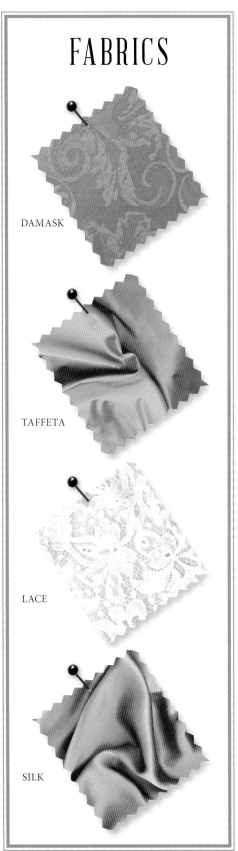

FABRICS

DAMASK

TAFFETA

LACE

SILK

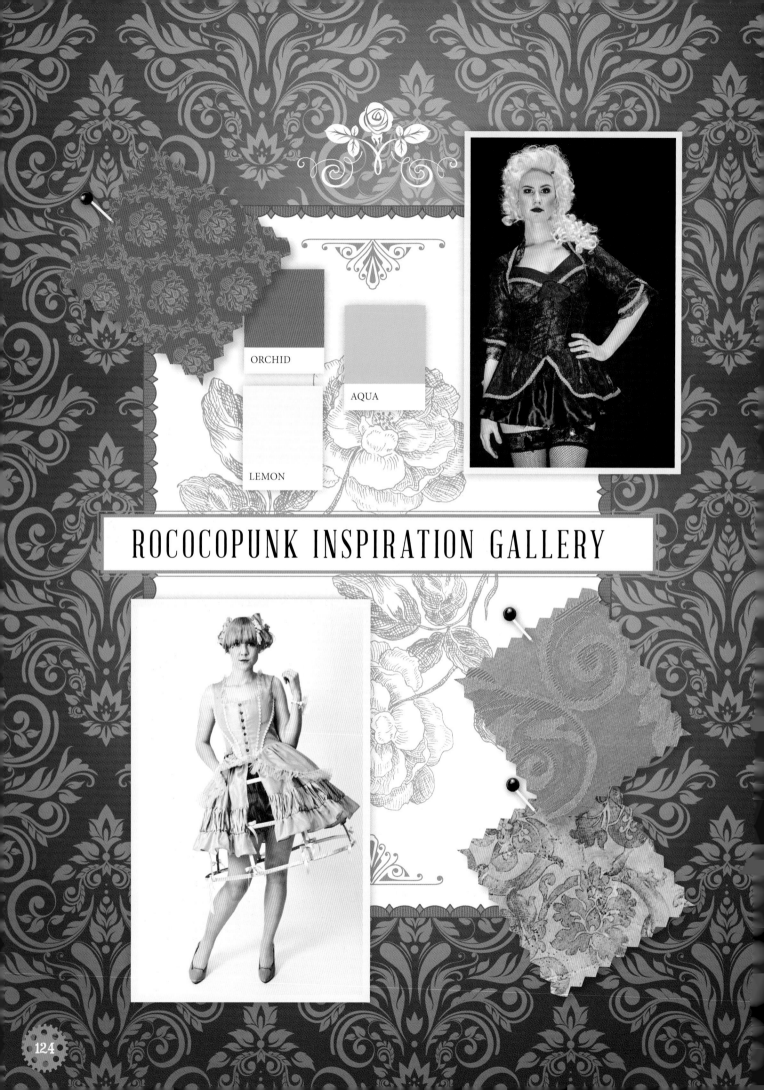

ORCHID

AQUA

LEMON

ROCOCOPUNK INSPIRATION GALLERY

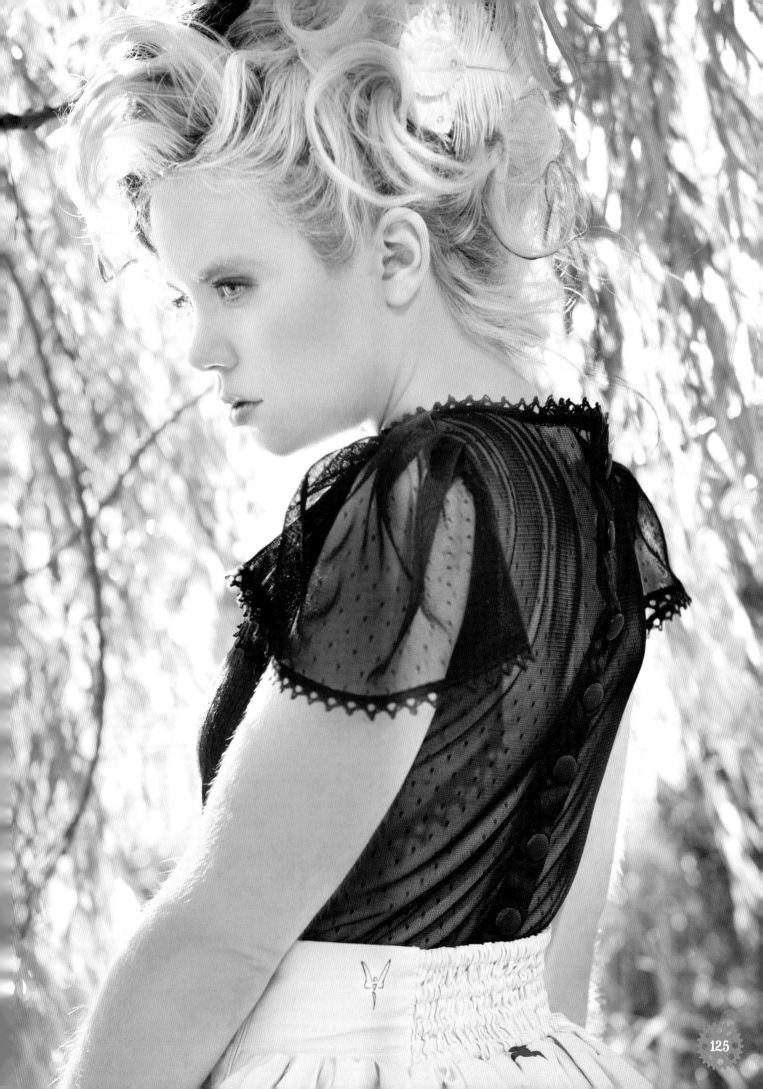

CROQUIS TEMPLATES

BASIC FEMALE

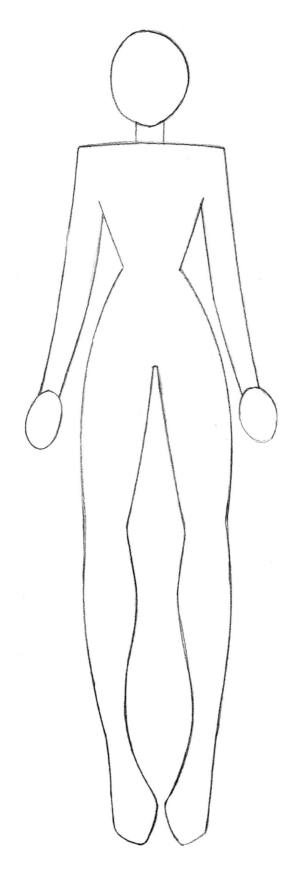

BASIC MALE

ABOUT THE DESIGNER

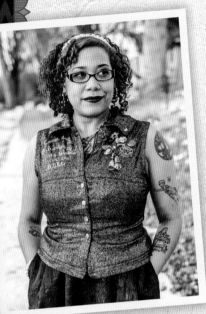

AFTER STUDYING at the Perpich Center for Arts Education, the College of Visual Arts (St. Paul), and the Minneapolis Community and Technical College for Apparel Technologies, Samantha R. Crossland began her design career with her label "Blasphemina's Closet" in 2000. After closing "Blasphemina's Closet" in September of 2013, she started anew with her new eponymous label "Samantha Rei." "Samantha Rei" embodies the sweetness and femininity that has come to be expected from the designer.

Samantha draws her inspiration from such illustrators as Chris Riddell, Brom, Tony DiTerlizzi, Brett Helquist, and Mihara Mitsukazu, as well as stories like *Alice in Wonderland* and *Snow White*. Her hero, Alexander McQueen, along with designers Vivienne Westwood, Hirooka Naoto, John Galliano, Victorian Maiden, and Anna Sui, have greatly influenced her style.

Samantha strives to help women feel confident, strong and comfortable in their own skin. She believes they can all be beautiful warriors. To learn more about Samantha, visit www.samantharei.com.